Davide Panagia
Ten Theses for an Aesthetics of Politics

David Golumbia
The Politics of Bitcoin: Software as Right-Wing Extreme.

Sohail Daulatzai
Fifty Years of *The Battle of Algiers*: Past as Prologue

Gary Hall
The Uberfication of the University

Mark Jarzombek
Digital Stockholm Syndrome in the Post-Ontological Age

N. Adriana Knouf
How Noise Matters to Finance

Andrew Culp
Dark Deleuze

Akira Mizuta Lippit
**Cinema without Reflection: Jacques Derrida's Echopoiesis
and Narcissism Adrift**

Sharon Sliwinski
Mandela's Dark Years: A Political Theory of Dreaming

Grant Farred
Martin Heidegger Saved My Life

Ian Bogost
The Geek's Chihuahua: Living with Apple

Shannon Mattern
Deep Mapping the Media City

Steven Shaviro
No Speed Limit: Three Essays on Accelerationism

Jussi Parikka
The Anthrobscene

Reinhold Martin
Mediators: Aesthetics, Politics, and the City

John Hartigan Jr.
Aesop's Anthropology: A Multispecies Approach

Against Aesthetic Exceptionalism

Forerunners: Ideas First

Short books of thought-in-process scholarship, where intense analysis, questioning, and speculation take the lead

FROM THE UNIVERSITY OF MINNESOTA PRESS

Against Aesthetic Exceptionalism

Arne De Boever

University of Minnesota Press

MINNEAPOLIS

LONDON

Excerpt from "Pedestrian at Best," performed by Courtney Barnett, written and composed by Courtney Barnett, published by Third Side Music, used by permission.

Portions of chapters 2 and 4 previously appeared in a different form in "Art and Exceptionalism: A Critique," *boundary 2* 45, no. 4: 161–81; used by permission of Duke University Press.

Published by the University of Minnesota Press, 2019
111 Third Avenue South, Suite 290
Minneapolis, MN 55401–2520
http://www.upress.umn.edu

For Alex

Because is not the characteristic of . . . what is called, using a very feeble word, "wisdom" in relation to philosophy precisely to dissolve the event?

—FRANÇOIS JULLIEN, *The Silent Transformations,* trans. Krzysztof Fijalkowski and Michael Richardson

Tell me I'm exceptional I promise to exploit you.

—COURTNEY BARNETT, "Pedestrian at Best," *Sometimes I Sit and Think, and Sometimes I Just Sit.*

Contents

Introduction: The Toporovski Affair

ON OCTOBER 20, 2017, an exhibition titled "From Bosch to Tuymans: A Vital Story" opened at the Museum voor Schone Kunsten (Museum of Fine Arts) in Ghent, Flanders (Belgium), where it was supposed to run through February 28, 2018. The exhibition was curated by the internationally recognized art critic and art historian Catherine de Zegher, who had become the museum's director in 2013. It included works of early twentieth-century Russian avant-gardist art attributed to Wassily Kandinsky and Kazimir Malevich, among others. Through those works, de Zegher ambitiously sought "to rewrite the history of the Russian avant-garde." Not part of the museum's permanent collection, the works had never before been publicly exhibited. It was revealed that the museum had them on loan from the Dieleghem Foundation, a charity established by the Russian/naturalized Belgian Igor Toporovski who (with his wife Olga Toporovski) owns the castle in Belgium after which the charity is named.[1]

However, as soon as—and even before—the works from the Toporovski collection had gone on show, doubts were raised about their authenticity. After all, if the works included in the exhibition were authentic, the museum would have had the exhibition of the century, one for which major institutions in major cities would have *killed*. Something about the works just seemed

1. Apparently, the Toporovskis are planning to turn the castle into a museum to exhibit their extensive art collection. See Colin Gleadell, "Experts Say Russian Modernism Show at Ghent Museum is 'Highly Questionable,'" *Artnet News*, January 15, 2018, https://news.artnet.com /exhibitions/experts-say-russian-modernism-show-ghent-museum-highly -questionable-1198757.

too good to be true. Moreover, the Toporovskis' record in the art world wasn't exactly clean: some ten years earlier, the discovery of a fake Malevich and Kandinsky had been traced back to a sale by . . . Igor Toporovski.[2] Shortly after the exhibition opened, a public letter appeared in *The Art Newspaper*, signed mostly by art dealers and collectors (as well as a few art historians, curators, and one independent scholar), that claimed that the works from the Toporovski collection featured in the show were "highly questionable."[3] If de Zegher, when she became the museum's director in 2013, had said she wanted to create an "open museum," the letter pointed out that surely *this* was not the openness she would have wanted.

That letter landed on the desk of a politician, the Flemish Minister of Culture and the Media, the liberal Sven Gatz. Apparently, it had been Gatz who had initially put de Zegher in touch with the Toporovskis after he had seen some of the Toporovskis' art collection at their home. Because the Toporovski affair was taking on larger proportions by the day—because it was turning, precisely, into an *affair*—Gatz decided to become involved again, this time as a politician who knows nothing about art and whose hands were therefore clean in the entire situation: he had merely put de Zegher and the Toporovskis in touch. Gatz now pressed the city of Ghent to put together a commission to investigate the works in the exhibition.

2. Sarah Cascone, "Belgian Museum Removes Show of Disputed Russian Avant-Garde Works after Damning Exposé," *Artnet News,* January 30, 2018, https://news.artnet.com/exhibitions/russian-avant -garde-exhibition-closes-expose-1210742. For a more extensive account in English, see Simon Hewitt, "The *Art Newspaper* Exposé Helps Close Dubious Avant-Garde Art Display in Belgian Museum," *The Art Newspaper,* January 29, 2018, https://www.theartnewspaper.com/news/the-story -behind-the-dubious-russian-avant-garde-art-show-in-ghent-museum.

3. "Arts Professionals Accuse Ghent Museum of Exhibiting Unauthenticated Works," *Artforum,* January 16, 2018, https://www .artforum.com/news/arts-professionals-accuse-ghent-museum-of -exhibiting-unauthenticated-works-73539.

Another public letter followed in the Flemish newspaper *De Standaard,* signed not by dealers and collectors this time but by representatives of important institutions in the Flemish art world.[4] It, too, openly questioned the authenticity of the exhibited works but it specifically charged the museum and its director with having neglected all deontological codes and rules during the preparation of the exhibition. Rather than being concerned with the authenticity of the works, the letter focused on the *modus operandi* of the museum and how it reflected back on the Flemish museum world in general.

An adjusted commission was created to look into that, and during questioning de Zegher confirmed that the museum had most certainly followed standard procedure during the preparation of the exhibition. Very quickly, however, it was revealed that the experts she claimed had been consulted during the vetting of the questionable works' provenance, had in fact not actively been involved in that process at all.[5] On the basis of this new information, and due to increased media pressure, de Zegher was then temporarily suspended as museum director, even if during that time she remained an official of the city of Ghent, which is technically her position (the city "lends" her to the museum as director). On March 14, 2018, newspapers revealed that Ernst & Young had been engaged to do an audit of the museum to see whether proper procedures had indeed been followed during the preparation of the exhibition.[6] After months of silence, another open letter was published on October 10, 2018, in which many major artists, art critics, and curators expressed their support for de Zegher and criticized the curator's "trial by media."[7] At this point, the museum

4. "De Imagoschade Na Toporovski is Groot," *De Standaard,* March 5, 2018, http://www.standaard.be/cnt/dmf20180304_03390328.

5. Geert Sels, "De Zegher Loog Gentse Politici Voor," *De Standaard,* March 7, 2018, http://www.standaard.be/cnt/dmf20180306_03394363.

6. gvds. "Ernst & Young Doet Audit in MSK Ghent," *De Standaard,* March 14, 2018, http://www.standaard.be/cnt/dmf20180314_03409354.

7. Sarah Cascone, "Luc Tuymans, Giuseppe Penone, and Other Art-

audit had not yet been concluded; there was still no news about the authenticity of the works.

Finally, for now, on October 17, 2018, de Zegher and Toporovski held a press conference to announce that a material and technical analysis performed in European laboratories on ten of the works that had been exhibited, proves that the works are authentic. It is unclear what exactly is meant by "authentic": while such analysis may prove that the works date from the 1920s, it does not necessarily prove that they were made by the actual artists to whom the museum had ascribed the works.[8] In a letter titled "Fake Art or Fake News?" that was made available at the press conference and will at a later time be published in the art magazine *Hart,* de Zegher recounts some of the facts of the case—the letter does not comment on the Toporovskis' reputation in the art world—and points out its economic (financial) and political dimension. She highlights, for example, that it was initially art dealers who questioned the work and notes the implications of the affair and her "trial by media" for "our democracy."[9] The letter also announces that a book will be published in spring 2019 detailing all of the facts of the affair, including all the art historical, archival, literary, material, and technical evidence proving the authenticity of the works in question.

Those were the facts, as they say, or the facts to the extent that I was able to confirm them based on the reporting that was done about the affair. And I want to emphasize, before I get started, that I do not in any way want to discredit here the facts, or the attempt

World Figures Defend Museum Director after Russian Forgery Scandal," *Artnet News,* October 11, 2018, https://news.artnet.com/art-world/artists -art-professionals-defend-ghent-museum-director-russian-forgery-scandal -1369207

8. Geert Sels, "Toporovski en de Zegher Claimen: 'Werken Zijn Authentiek,'" *De Standaard,* October 17, 2018, http://www.standaard.be/cnt /dmf20181017_03852188.

9. Catherine de Zegher, "Fake Art or Fake News?" https://www.scribd .com/document/391046833/Tekst-De-Zegher#from_embed.

to get the facts right. This may be a critical tale about fake art, but that is not the same as a tale about fake news. Fake art is still within the realm of the aesthetic. Fake news is no news at all.

To be very clear: my goal in what follows is not to cast judgment on the works from the Toporovski collection or even on the museum. I leave that to the art *connaisseurs* and the politicians (given that a public institution is involved). I should add that de Zegher's qualities as an art critic and curator are, in my view, beyond doubt. My interest is instead philosophical and takes its cue from de Zegher's comments about the economic and political dimensions of the affair. I would like to think a bit more about how this Toporovski trouble is made possible. My suggestion—provocation—will be that the Toporovski affair is enabled by what I call *aesthetic exceptionalism*.[10] Briefly put, aesthetic exceptionalism names the belief—and I choose that word purposefully, as will soon become clear—that art and artists are *exceptional*. Before anyone gets offended, let me quickly add that I do not intend to argue the opposite: that art and artists are somehow *normal*. Everyone knows they are not. To break out of that simplistic opposition between the norm and the exception, which structures aesthetic exceptionalism, I propose instead a theory of *unexceptional art*. Neither exceptional nor normal, unexceptional art manages to be a kind of antidote to the exceptionalism that can be found in much contemporary aesthetic theory.[11]

10. I am not the first to use this term in print, but as far as I know, the content I give to it is original. Jon Robson already used this book's title as the title for a chapter he contributed to the book *Art and Belief* (ed. Ema Sullivan-Bissett, Helen Bradley, and Paul Noordhof [Oxford: Oxford University Press, 2017]). Robson's work is in aesthetic epistemology, however, and pursues a related but different angle into the issue of aesthetic exceptionalism through its focus on "belief pessimism" in relation to aesthetic judgment.

11. Let me note that while I focus on visual art here, I consider this situation to apply across the visual, performing, and literary arts. Aesthetic exceptionalism explains, for example, the difference in honoraria paid to creative writers and scholars when they are invited to speak about their

But why the need for an antidote? In what way, exactly, is aesthetic exceptionalism a poison? And why this move from the exception into the direction of the norm, only to hold back from the norm through a continued attachment to the exception (as the term un-*exceptional* makes evident[12])? I want to question aesthetic exceptionalism first and foremost from a political perspective, with attention to political exceptionalism and its complicated relation to democracy, a regime that is sometimes opposed to political exceptionalism and sometimes described in those very terms—as politically exceptional. To put it a little ambitiously, one could say that I am interested in a form of political reason and the ways in which it is also aesthetically active, and supported even by aesthetics. This line of questioning will focus on the sovereign figure of the artist as genius. Along the way, the exceptionalist art market—art's economic exceptionalism—will be considered as well. In that consideration, the distinction between the original and the fake will be my central concern. This is a good mo-

work. If the creative writer is paid vastly more, and often to read from work that has already been published, this is not because they generally do not have a fixed income, as some maintain. It is because, unlike scholars, they are considered exceptional. The question-and-answer sessions after their talks often make this explicit. If the scholar is usually asked about the content of the (generally new) material they have presented, the creative writer is asked about their writing discipline. No one ever asks the scholar how they write. People want to *be* the creative writer; they want to know their secret. The scholar has no such cachet. The creative writer has the touch of the theological that the scholar lacks. The exception here would be the star scholar, often a theorist, who shares the exceptionalist allure of the creative writer. In the latter case, one may want to speak of "academic exceptionalism" instead. Much abusive behavior in the university is enabled by such academic exceptionalism.

12. In its relation to the term it qualifies, the prefix "un" is similar to the prefix "post," which, in Wendy Brown's useful understanding, "signifies a formation that is *temporally after but not over* that to which it is affixed" (Wendy Brown, *Waning Sovereignty, Walled Democracy* [New York: Zone Books, 2010], 21). Indeed, *Post-Exceptionalism*—a term that has been used in policy studies—may have been another possible title for this book.

ment to recall that the initial public response to the exhibition of works from the Toporovski collection came from a group of art dealers and collectors, rather than from art historians, curators, or art critics. Why might that be so? Art is a particularly good place to question exceptionalism, because it is where the two lines of questioning that I've opened up coincide. More comprehensively, then, *Against Aesthetic Exceptionalism* pursues a transgressive critique of a widespread political and economic reason of art that the Toporovski affair lays bare.

In chapter 1, I explain what I mean by both aesthetic and political exceptionalism as well as how I consider the two to be related. My focus is on an exceptionalism that many have understood as undemocratic: the theory of sovereignty as the power to decide on the state of exception as it can be found in the work of the twentieth-century German constitutional scholar Carl Schmitt. Schmitt is a controversial figure due to his affiliation with Nazism. I build on the work of other scholars to identify a certain Schmittian exceptionalism in the work of various contemporary theorists of art, specifically in the work of the French philosophers Alain Badiou and Jacques Rancière.

But do such traces of Schmitt—and of a certain kind of Schmitt, as will become clear—cast a shadow over all political and aesthetic exceptionalisms? In chapter 2, I look at the work of a small range of contemporary political philosophers (Bonnie Honig, Chantal Mouffe, and Judith Butler) who have arguably sought to reclaim exceptionalism from Schmitt for democratic purposes. Following both Honig and Butler's discussion of indigenous politics in this context, I turn to a controversial work of contemporary art, Sam Durant's *Scaffold,* and read it as a site where aesthetic exceptionalism as well as various political exceptionalisms are productively played out against each other. As such, these first two chapters revolve around a sovereign conception of the artwork as well as the artist.

If the focus on democratic exceptionalism already presented a minor transgressive gesture within the logic of aesthetic exceptionalism, in chapter 3 I build on aesthetic theory by the

Korean-German philosopher Byung-Chul Han and the French philosopher Bernard Stiegler to begin to develop an alternative to aesthetic exceptionalism. While Han and Stiegler provide the historical and especially philosophical underpinnings for this, the chapter pursues an in-depth reading of a series of paintings by the little-known Los Angeles–based artist Alex Robbins. Titled "Complements," these works can be understood (through the lens of both Han's and Stiegler's thought) as conceptual works that undermine—in a much more radical way than *Scaffold*—the exceptionalism on which the contemporary Western art world, and in particular the contemporary Western art market, is built. While the sovereign figure of the artist as genius is still present in this chapter, the chapter also establishes a shift toward the exceptionalist notion of the original with which *Against Aesthetic Exceptionalism* began.

In chapter 4, I return to the Toporovski affair from an economic point of view and propose the notion of unexceptional art as the end of aesthetic exceptionalism. After having philosophically grounded this alternative in chapter 3, I also articulate its political consequences through a discussion of destituent power and anarchy in the work of the Italian philosopher Giorgio Agamben, specifically his book *The Use of Bodies,* which completes the multivolume *Homo Sacer* project in which Agamben has taken on the exceptionalist logic of modern Western power. If Agamben's project was overwhelmingly political, I seek to draw out its consequences for aesthetic exceptionalism. Second, and returning to the theoretical references from chapter 1, I pursue here the notion of democratic *anarchy* in the works of Jacques Rancière and the literary theorist Stathis Gourgouris as marking the politics of the alternative theory of aesthetics that this book seeks to theorize.

Overall, this book thus comes down more on the political than the economic side of things. It is a work of democratic political theory rather than a work of Marxism. This is for specific reasons. While one may expect the commodity to be an original (rather than an imitation), one does not expect it to have been produced

by an exceptional worker. The art work is a better target for my two lines of questioning because in it the exceptionalism of the original and of the person who made it are combined. With luxury commodities, however, one can already see these distinctions shift: here, the suggestion is often (in advertising, for example) that the commodity was indeed made by an exceptional person, and just for you. The goal of such a suggestion, as I see it, would be to lift the luxury commodity to the level of the artwork, with all of the exceptionalism this implies. The particular set of issues that I am interested in, then, are better realized in the artwork than in the commodity, and necessitated the focus on democratic theory rather than Marxism. It is, in my view, not only the more appropriate but also the more original path to pursue.

In the end, and echoing Emily Apter's work on unexceptional politics, this book is a plea for unexceptional art. By this I mean an understanding of art (rather than actual works of art that one can point to) that would unwork the aesthetic, political, and economic exceptionalisms that structure the art world. This does not mean, as I already indicated, that I seek to do away with exceptionalism altogether: the notion of the un-*exceptional* marks an attempt, precisely, to hold on to exceptionalism's trace in order to open up a path toward other kinds of exceptionalism. *Against Aesthetic Exceptionalism* does not propose an aesthetic relativism according to which anything is art, and anyone is an artist. Unexceptional art holds on to a trace of the exceptional in aesthetic judgment, the economic valuation of art, and the verticality of art's political reason, because it considers such traces to be valuable. Before I am misunderstood, then, let me close by stating—again, a little provocatively—that this is therefore anything but another manifesto for horizontalism.

1. Aesthetic and Political Exceptionalism

WHAT IS AESTHETIC EXCEPTIONALISM? The phrase sounds ugly and difficult, like a piece of theory jargon that ought to be assigned to the trash heap of contemporary thought. However, many are no doubt familiar with the beliefs I would associate with this notion. I am thinking for example of Alain Badiou, who in his book *The Century* understands the effect of art as "forcing a thinking to declare, in its area of concern, the state of exception"[1]—and he values this effect positively. When Steven Corcoran characterizes the connection between aesthetics and politics in Jacques Rancière's thought, he suggests (but I will have to nuance this suggestion later) that in Rancière "art and politics can be understood, such that their specificity is seen to reside in their contingent *suspension* of the rules governing normal experience."[2] Art and politics find each other in the fact that both depend on "an innovative leap from the logic *that ordinarily governs human situations.*"[3] Art and politics find each other, it seems, in their shared exceptionality.

Where have we heard this before? In an early response to Badiou's book *Being and Event,* Jean-François Lyotard suggests that Badiou's theory of the subject strangely "mirrors" the twentieth-century German constitutional scholar Carl Schmitt's theory of the sovereign as he who decides on the state of excep-

1. Alain Badiou, *The Century,* trans. Alberto Toscano (Cambridge: Polity, 2007), 160.

2. Steven Corcoran, "Editor's Introduction," in Jacques Rancière, *Dissensus: On Politics and Aesthetics,* ed. and trans. Steven Corcoran (London: Continuum, 2010), 1.

3. Corcoran, 1.

tion.[4] In the first chapter of his book *Political Theology: Four Chapters on the Concept of Sovereignty*,[5] Schmitt declares that "sovereign is he who decides on the exception"[6] (in the German original, "Souverän ist, wer über den Ausnahmezustand entscheidet"[7]). The stand-alone opening sentence reads like a sovereign decision itself. In it, Schmitt decides, as a sovereign author, who is sovereign. In English, the sentence is suspended between the words "sovereign" and "exception," which are the most relevant terms here. In German, the language is more precise (exception is "state of exception" in the original German) and the sentence is now suspended between "sovereign" and "decision," which foregrounds the decision rather than the state of exception.

The project of Schmitt's chapter is, evidently, to define sovereignty. Some would, no doubt, tend to look at the normal situation to do so: who guarantees the rule of law? Surely, that is the sovereign. But Schmitt's answer is different. If one wants to find out in any given situation who is sovereign, one must find out who decides on the state of exception. This is why sovereignty is, in his view, a borderline concept: it can only be understood from the extreme limit ("*extremus necessitatis casus*," an extreme case of necessity[8]). For Schmitt, the exception comes first ("the rule . . . derives only from

4. Philippe Lacoue-Labarthe, Jacques Rancière, Jean-François Lyotard, and Alain Badiou, "Liminaire sur l'ouvrage d'Alain Badiou 'L'être et l'événement,'" *Le Cahier* (*Collège Internationale de Philosophie*) 8 (1989): 201–25, 227–45, 247–68.

5. Some of the discussion of Schmitt that follows is taken from my review of Santiago Zabala's book *Why Only Art Can Save Us: Aesthetics and the Absence of Emergency* (New York: Columbia University Press, 2017), published as "Art and Exceptionalism: A Critique," *boundary 2* 45, no. 4: 161–81.

6. Carl Schmitt, *Political Theology: Four Chapters on the Concept of Sovereignty,* trans. George Schwab (Cambridge, Mass.: MIT Press, 1985), 5.

7. Carl Schmitt, *Politische Theologie: Vier Kapitel Zur Lehre Von der Souveränität* (Leipzig: Duncker & Humblot, 1922), 9.

8. Schmitt, *Political Theology,* 10. Further page citations to this work will appear in the text.

the exception"); it "proves everything." Understood in this way, the exception has something "vital" [15] to it: "In the exception," Schmitt writes with echoes of Nietzsche, "the power of real life breaks through the crust of a mechanism that has become torpid by repetition" (15)[9] In order to understand what that mechanism is, one has to understand what happens in the state of exception.

The situation that the phrase "state of exception" refers to is very particular: in it, the law temporarily suspends itself in order to enable sovereign power to maintain order (and protect the law). This is not a situation of "anarchy and chaos" (12) as Schmitt is careful to point out. It is not a situation in which the law is destroyed.[10] Rather, we are talking about a constitutionally guaranteed temporary suspension of the constitution ("According to article 48 of the German constitution of 1919 . . ." [15]), a situation in which the law recedes but order is maintained. One could call this "extraordinary order" and distinguish it from what Schmitt suggests to be "ordinary" order. The state of exception enables him to point to the phrase *"legal order"* to explain that in a state of exception, the two terms that make up that phrase get forced apart, are "dissolved into independent notions" (12) with the law receding to a minimum while order (absolute order, in this case) is maintained. It is in such situations, Schmitt argues, that sovereign power is revealed. Schmitt does not tell us on what criteria the sovereign decides on the state of exception. He does not have the audacity to lay this out. This can only be decided by the sovereign, based on the sovereign's "competency." What is certain, however,

9. This has lead commentators to distinguish a bio-normativism in Schmitt's work. See Kirk Wetters, "The Rule of the Norm and the Political Theology of 'Real Life' in Carl Schmitt and Giorgio Agamben," *diacritics* 36, no. 1 (2006): 31–46; here in particular 35 and further.

10. The translator notes the importance of this distinction in Schmitt's book *Dictatorship,* which distinguishes between the presidential power to decide on the state of exception (commissarial dictatorship) and the power to abrogate the constitution (sovereign dictatorship). Schmitt, *Political Theology,* 7.

is that the state of exception is declared in name of "public safety and order, *le salut public* [public well-being]" (6)

Schmitt argues that the decision on the state of exception has always been at the core of sovereignty. He finds it in Bodin, for example, in the sixteenth century, and while "the vivid awareness of the meaning of the exception" (14) is maintained in the seventeenth century, Schmitt notes that by the eighteenth it has gone missing: "the exception was something incommensurable to John Locke's doctrine of the constitutional state and the rationalist 18th century" (13–14); "emergency law was no law at all for Kant" (14). But, Schmitt argues, "it should be of interest to the rationalist that the legal system itself can anticipate the exception and can 'suspend itself'": "from where does the law obtain this force, and how is it logically possible that a norm is valid except for one concrete case that it cannot factually determine in any definitive manner?" (14).

Schmitt is telling his readers that the key activity of sovereign power is to decide on the temporary suspension of the law in the state of exception. To do so, sovereignty takes up a peculiar position inside/outside of the law ("although [the sovereign] stands outside . . . he nevertheless belongs" [7]). What makes sovereignty? The state of exception. What makes the state of exception? The law, which includes the sovereign possibility of its own suspension—a kind of "violence" (9)—in cases that the law could not possibly anticipate (future situations, as Schmitt makes clear: "the precise details of an emergency cannot be anticipated" [6]). In Schmitt's typically circular reasoning, the exception makes the sovereign, the sovereign the exception.

Taking their cue from Lyotard, Peter Hallward, Nina Power, and Colin Wright have all considered the similarities and differences between Schmitt and Badiou. Indeed, the connection between Schmitt and Rancière has received some discussion as well. Hallward follows Lyotard in noting the resonances between Badiou and Schmitt but very quickly discards the issue.[11] That a more

11. Peter Hallward, "Badiou Absolutiste?" in *Badiou: A Subject to Truth* (Minneapolis: University of Minnesota Press, 2003), 284–91.

careful elaboration is needed becomes quite clear in Nina Power's consideration of these same resonances, which she is more willing to acknowledge even though she clearly (and rightly) distinguishes between Badiou and Schmitt's "political aims."[12] It is Colin Wright who has gone the furthest on this count, arguing—or rather, as he puts it, "believing"—that "the most promising theoretical tool available today for thinking beyond and against the logic of the exception [which Wright associates with Schmitt] . . . is Alain Badiou's philosophy of the event."[13] The problem is that Wright is rather too good at drawing out the "proximities" between Schmitt and Badiou, which amount to four pages of his article—the same length as his discussion of their "differences." Whereas he discusses five similarities between Schmitt and Badiou, the differences really only amount to one. Finally, it is Panu Minkkinen who has argued that Rancière is all too quick to dismiss the connections of his work to Schmitt.[14]

Given the echoes of Schmitt in those thinkers' aesthetic theories, it is worth noting legal scholar Paul Kahn's observation in a book about political theology that Schmitt's definition of sovereignty links sovereignty both to God *and to the artist*.[15] The tie to God is probably fairly straightforward: Schmitt's theory of sovereignty famously states that "all significant concepts of the modern theory of the state are secularized theological concepts."[16] Thus, Schmitt argues that the exception—a situation in which the normal rule of

12. Nina Power, "Towards an Anthropology of Infinitude," in *The Praxis of Alain Badiou, ed.* Paul Ashton, A. J. Bartlett, and Justin Clemens, 309–38 (Melbourne: Re-Press, 2006), 321.

13. Colin Wright, "Event or Exception? Disentangling Badiou from Schmitt, or, Towards a Politics of the Void," *Theory & Event* 11, no. 2 (2008): 1–18 at 3.

14. See Panu Minkkinen, "Rancière and Schmitt: Sons of Ares?" in *Rancière and Law,* ed. Lerma López Mónica and Julen Etxabe, 129–48 (New York: Routledge, 2018).

15. Paul Kahn, *Political Theology: Four New Chapters on the Concept of Sovereignty* (New York: Columbia University Press, 2012), 128.

16. Schmitt, *Political Theology*, 36.

law is suspended—is a secularized version of the theological notion of the miracle (walking on water, turning water into wine, and so on). The sovereign, in this configuration, is a secularized version of God, or at least of God incarnated into his son Jesus.

What about the connection of the sovereign to the artist? This is maybe less obvious, unless one considers the simple fact that the sovereign *creates* to be enough evidence already for this connection—and there definitely is something sovereign and theological to the *creating* artist. But one finds echoes of precisely this in Badiou, for whom art does something that is quite similar to what the sovereign does, i.e. it declares a state of exception (in Badiou's words) whereas the sovereign decides the state of exception (in Schmitt's words). When Corcoran characterizes the connection between aesthetics and politics in Rancière by focusing on art's "contingent *suspension* of the rules governing normal experience," that language could just as well have been taken from Schmitt's theory of sovereignty. Particularly striking is Corcoran's use of the verb "suspend": that's the key activity of sovereignty, as Schmitt sees it—*suspending* the law.[17]

There are differences, of course, for example when it comes to the goals: in Schmitt, the suspension of the law happens in an attempt to preserve it. In Rancière, the suspension happens to accomplish the law's transformation—which is obviously different from what one finds in Schmitt. Given that Schmitt became a Nazi and that Rancière critically defends democracy, one might want to distinguish (I understate my claim) between a fascist and a democratic politics of exception, and in the case of Badiou

17. While Schmitt is my main reference in this consideration of the connections between the sovereign and the artist, Santiago Zabala has shown that Martin Heidegger's thought must also be considered in this context. See Zabala, *Why Only Art Can Save Us*. Indeed, Heidegger's work from the mid-thirties—which engages Schmitt's thinking and proposes an exceptionalist theory of art—considers precisely the connections I lay out here. I would like to thank Martin Woessner for this observation. See also my review of Zabala: "Art and Exception: A Critique."

perhaps also a communist politics of the exception.

To make these distinctions, one would have to ask in what way, to what extent, the politics of art, and specifically the exceptionalist "suspension" that art often prides itself on, is any different from the exceptionalist politics of Schmittian sovereignty. Put a bit more subversively: *in what way might the unreflexive attachment to an exceptionalist politics-of-art-that-suspends, often risk being a secret promotional campaign—in what we like to imagine as the critical and progressive sphere of the arts—for the Schmittian politics of the state of exception that many who are active in the arts would, politically, claim to be against?* And if art's exceptionalism is *not* that, how might it differ from the exceptionalism we find in Schmitt? If art's politics of exceptionalism is a democratic politics, how is that the case?

I should add that I focus here on Schmitt as a theorist of the law's suspension, which is the reading that he has most commonly received. But there are others—I am thinking of Andreas Kalyvas in particular—who have sought to draw out the normative dimension of his work, namely his concomitant interest in the making of law rather than the law's suspension, and indeed his contributions as a democratic theorist.[18] In a democracy, Schmitt would likely have argued, it is the people who are sovereign and hold the political power to suspend the law. Schmitt would then be considered to insist on the political power of the people in the democratic liberal constitutional regime whose depoliticization he drew into question. This is part of the reason his work has found resonance with scholars like Chantal Mouffe, to whom I will turn in the next chapter. However, it is difficult to maintain such a reading of Schmitt as a democratic theorist without letting it be eclipsed by

18. See, for example, Andreas Kalyvas, "Carl Schmitt and the Three Moments of Democracy," *Cardozo Law Review* 21, no. 5 (1999–2000): 1525–65. For his reading, Kalyvas focuses on chapter 18 of Schmitt's book *Constitutional Theory,* trans. Ellen Kennedy (Durham, N.C.: Duke University Press, 2008).

the rise of National Socialism and the normalization of the state of exception that it brought.

Before I move on, let me also note the complexity of the relation of the political to the aesthetic in Schmitt's work, and the reception it has received. Neil Levi lays this out brilliantly in an article titled "Carl Schmitt and the Question of the Aesthetic."[19] If I am suggesting that the aesthetic exceptionalisms one finds for example in Badiou and in Rancière take their echo from Schmitt, it is worth taking into consideration for example Richard Wolin's criticism of Schmitt, his charge that Schmitt precisely "aestheticizes" politics (which, via Walter Benjamin's famous analysis, can lead to the charge of "fascism"). Schmitt does so, Wolin claims, because he focuses on "rupture, discontinuity, and shock, which Wolin claims as 'aesthetic values.'"[20] The exception *is* aesthetic; when Schmitt proposes a concept of the *political* that revolves around the exception, he *aestheticizes* politics. It is not so much that contemporary theories of the aesthetic take after Schmitt. Rather, there was already an aesthetics at work in Schmitt. And indeed, before Wolin, Peter Bürger had argued that "Schmitt's 'exception' is the political equivalent of the Kantian aesthetic, which resists the categories of the understanding, and that the sovereign who freely decides is the political equivalent of the Kantian genius who gives rules to himself."[21]

As Levi points out,[22] not all scholars agree with this: Andrew

19. Neil Levi, "Carl Schmitt and the Question of the Aesthetic," *New German Critique* 101 (2007): 27–43.

20. Levi, 35.

21. Victoria Kahn, "Hamlet or Hecuba: Carl Schmitt's Decision," *Representations* 83 (2003): 67–96 at 68–69. This is, in my view, a reading of the Kantian aesthetic that focuses on the sublime rather than on the beautiful; in addition, it proposes a sovereign understanding of autonomy, which leads to an identification of two terms that should be kept apart. I will return to this in the next chapter. However, I don't think there can be any doubt about the exceptionality of Kant's philosophy on this count and its transcendental attachment to a priori principles.

22. Levi, "Carl Schmitt," 32.

Norris and the already-mentioned Andreas Kalyvas have challenged this reading, pointing out that Schmitt himself wanted to keep the political and the aesthetic separate, and taking him at his word for this.

One other curious element that Levi notes—and this can be tied to Bürger's point about the Kantian aesthetic—is Schmitt's association of the aesthetic, and in particular aesthetic autonomy (which he also glosses as the idea that "artistic genius is sovereign"), with liberalism.[23] It is not so much the association of the aesthetic with liberalism that surprises, but the association of autonomy—tied here to sovereignty[24]—with liberalism. As Levi observes, "the diction practically invites us to consider structural similarities between the autonomous [sovereign] realms of the aesthetic and the political."[25] Schmitt will have none of it, and neither will many of Schmitt's readers. It is Levi, however, who insightfully draws out such similarities as well as differences, thus providing historical context and analytical depth to the relations between Schmitt's political exceptionalism and what I call aesthetic exceptionalism.

23. Levi, 41.

24. This tie of autonomy to sovereignty is not straightforward, and I intend to return to it in the next chapter. In his book *The Sovereignty of Art: Aesthetic Negativity in Adorno and Derrida* (trans. Neil Solomon [Cambridge, Mass.: MIT Press, 1998]), Christoph Menke points out that, for Adorno, autonomy and sovereignty make up the "antinomy of the aesthetic" (vii). But how, exactly, are the two connected? This is, Menke suggests, "the central task facing philosophical aesthetics" (viii). Certainly the problem is not that of philosophical aesthetics alone; political theory, too, has trouble articulating this difference. In his book *Genocide as Social Practice* (Newark, N.J.: Rutgers University Press, 2014), Daniel Feierstein provides a very limited account of sovereignty—he limits himself to a Schmittian/Agambenian take on the notion, defining sovereignty as a "camp"—but does give a useful account of autonomy as different from sovereignty (58–60 and 64–65). I have also found useful Roberto Russell and Juan Gabriel Tokatlian's articulation of autonomy in distinction to sovereignty in "From Antagonistic Autonomy to Relational Autonomy: A Theoretical Reflection from the Southern Cone," *Latin American Politics and Society* 45, no. 1 (2003): 1–24.

25. Levi, "Carl Schmitt," 41.

2. Democratic Exceptionalisms (On Sam Durant's *Scaffold*)

AS WILL BE CLEAR from my analytical (and, perhaps, all too crude, given Kalyvas's reading of Schmitt) distinction between fascist, democratic, and communist exceptionalisms, I do not think all exceptionalisms are the same. Certainly, I do not value all exceptionalisms equally. There are a few scholars who, in view of the contemporary political situation and partly as a criticism of a political Left that has been too focused on the withdrawal from power and the horizontal politics of the multitude, have begun to contribute to the project of rethinking exceptionalist politics, including art's exceptionalist politics, from the point of view of democracy. Very interestingly, such a project has tended to operate under the banner of "sovereignty," something that—surely—brings a frown to the faces of many in the arts—and perhaps especially those who think artists and art are "exceptional." Surely, they think, that would mean they are anything but "sovereign"?

Consider in this context the work of political philosopher Bonnie Honig, who in an article titled "Three Models of Emergency Politics" proposes that we must ask "how democratic theorists and activists might go further to democratize emergency, and to do so not to resist sovereignty but to claim it."[1] In other words, Schmittian sovereignty is not the *only* sovereignty that can become meaningful in a state of exception or emergency situation. To democratize emergency, she continues,

> means seeking sovereignty, not just challenging it, and insisting that sovereignty is not just a trait of executive power that must be chas-

1. Bonnie Honig, "Three Models of Emergency Politics," *boundary 2* 41, no. 2 (2014): 48.

tened but also potentially a trait of popular power as well, one to be generated and mobilized. Rather than oppose democracy and emergency, then, we might think about democratic opportunities to claim sovereignty even in emergency settings.[2]

Honig lays out different models for this: deliberative, activist, and legalist. It is through the emergency that "new forms of collective living"[3] can come about.

The deliberative model she associates with Elaine Scarry's position in *Thinking in an Emergency*, where Scarry advocates "a fully deliberative approach to emergency preparations in advance of any actual crisis."[4] This goes against Schmittian decisionism—what one gets instead is collective deliberation and the community building that it brings. But many other Schmittian elements remain intact: the friend/enemy distinction, for example, familiar to readers of Schmitt's *Concept of the Political*; or also the threat of war, the real possibility of war, as an organizing cause.

It is Honig's second, activist model, which she derives from the work of Douglas Crimp, that most obviously targets the friend/enemy distinction from a queer studies point of view, through its focus on promiscuity. In the middle of the AIDS crisis, Crimp developed promiscuity, which was under attack at the time, "as a form of life, and resisted its stigmatization by those moralists and pragmatists who treated promiscuity as an indulgence or as a sign of gay male immaturity."[5] To fight the reduction of human life to mere life in a state of emergency, Crimp (in Honig's reading) turns to "more life": to a higher, more intense form of living as opposed to its reduction to mere life. As opposed to Scarry's "devotion to deliberative processes and risk aversion," then, Crimp "sees the promises and pleasure of spontaneity."[6] For Crimp, "democracy is itself promiscuous."[7]

2. Honig, 48.
3. Honig, 49.
4. Honig, 50.
5. Honig, 55.
6. Honig, 57.
7. Honig, 57.

It is, finally, in the legalist approach—associated with Louis Freeland Post—that Honig finds elements of both Scarry and Crimp combined, of deliberation and promiscuity combined. Post was a proceduralist who was weary of proceduralism, and Honig appreciates this promiscuous approach to deliberation. Honig casts Post, whom she also discusses in her book *Emergency Politics*,[8] as someone who introduces us to "the paradox of politics."[9] This refers to a touchstone in Honig's work, namely Jean-Jacques Rousseau's problem of "how to design a good polity when, to get good law, you need good men to author it, but to get good men, you need good law to shape and socialize them"? She notes that this is a "chicken and egg" problem that, I would add, resonates with the problem of the state of exception itself, and whether it is the sovereign who makes the exception or the exception who makes the sovereign.[10]

As Honig had already discussed in detail in *Democracy and the Foreigner*,[11] Rousseau famously brings in a "lawgiver" who comes along to give people a law that they cannot generate themselves, only to remove himself from the political scene after that. Whereas this issue is usually situated at the origin of political communities, Honig actually points out that such scenes return in political communities on a daily basis, "as new citizens are born into a regime or immigrate into it, and old ones are resocialized into its expecta-

8. Bonnie Honig, *Emergency Politics: Paradox, Law, Democracy* (Princeton, N.J.: Princeton University Press, 2011).

9. Honig, "Three Models," 65.

10. In chapter 1, I have uncovered this particular issue in Schmitt's thinking about the state of exception. The state of exception, as I have discussed, is the mechanism through which Schmitt writes sovereignty into the law, but as the power to suspend it. The question for Schmitt, then, is not so much about whether it is the law or the sovereign that comes first, but the norm or the exception. He unambiguously states that the exception has priority, at least when it comes to thinking sovereignty: one must look at the exception rather than the norm to understand sovereignty.

11. Bonnie Honig, *Democracy and the Foreigner* (Princeton, N.J.: Princeton University Press, 2001).

tions and norms, and demands."[12] Honig appreciates Post because he reminds us that "the paradox of politics" is always there, that politics is always partly procedural and partly promiscuous. And both those elements, as well as their particular legalist combination, can come out of state-of-exception politics. In this way, state of exception politics actually revitalizes democratic politics, rather than accomplish the fascist suspension of democracy.

Honig's argument is a major shift in the discourse about the state of exception that, so far, I have considered largely within a Schmittian perspective, which tends to promote the state of exception's association with fascism. Honig taps into a different tradition—the thinking of the state of exception as democratic. The advantage of Honig's approach is that it enables one to develop a critique of the state of exception, a consideration of its legitimate versus its illegitimate uses, its democratic versus its fascistic uses. Honig thus turns the state of exception into a "critical" concept, a concept whose politics cannot in any sovereign way be decided but is perpetually under discussion. Merely by developing the democratic take on the exception, Honig challenges the sovereignty of this notion and begins to rethink it.

Chantal Mouffe does not use the term "sovereignty" in this context—I don't think it appears a single time in the two texts she devotes to Schmitt in *The Challenge of Carl Schmitt*—but her political thought is obviously influenced by Schmitt. In fact, when Mouffe seeks to think a truly political liberalism—a left liberalism as she calls it—she has in mind a liberalism that would incorporate Schmitt's friend/enemy distinction. It is true that by turning to Schmitt's text from 1927/1932, *Concept of the Political,* she avoids having to address the notion of sovereignty, which is associated with the text from 1922, *Political Theology.* At the same time, it is hard to avoid the connection between the two texts, because *Concept* begs the question of who is to decide on the determina-

12. Honig, "Three Models," 65.

tion of someone as friend or enemy. Such a decision, which is argu-ably ultimately a decision on the state of exception (for the enemy is the one who poses the threat of existential negation and thus may necessitate the suspension of the law), is made in Schmitt's thought by the sovereign. It is therefore the sovereign who lurks behind the friend/enemy distinction that is most visible in war.

While Mouffe does not want war, she does want the tension of Schmitt's concept of the political—she wants to rethink liber-alism from there. And so she transforms the antagonism of the friend/enemy distinction into the serious but more playful ago-nism of adversaries who seek to convince each other through a debate. It's important to note that there is no cultural relativism here. Also, Mouffe insists that the debate need not have only one rational solution; to think that such a solution can be found puts unnecessary pressure on the debate. She has in mind instead an "agonistic pluralism" where "the political"—"the dimension of antagonism that is inherent in human relations, antagonism that can take many forms and emerge in different types of social relation"[13]—is never plastered over by "politics"—"the ensemble of practices, discourses, and institutions which seek to establish a certain order and organize human coexistence."[14] The latter op-erates under conditions that are always "potentially conflictual, because they are affected by the dimension of 'the political.'"[15] Politics in Mouffe's view "domesticat[es] hostility and . . . [tries] to defuse the potential antagonism that exists in human relations."[16] Democracy's central question becomes then not "how to arrive at a consensus without exclusion"—a question whose answer she considers impossible from an *ontological* point of view (see, for ex-

13. Chantal Mouffe, *The Democratic Paradox* (New York: Verso, 2009), 101.

14. Mouffe, 101.

15. Mouffe, 101.

16. Mouffe, 101.

ample, "Agonistic Politics and Artistic Practices"[17])—but "the different way" in which the us/them opposition is established "in a way that is compatible with pluralist democracy."[18] The other is no longer the Schmittian enemy who must be existentially negated but "somebody whose ideas we combat but whose right to defend those ideas we do not put into question."[19] What this position aims for, then, is a position of "conflictual consensus."[20]

In Mouffe's view, it is the fact that this agonism always has a taint of the antagonistic to it that distinguishes her position from that of Honig who, she claims, "leaves open the possibility that the political could under certain conditions be made absolutely congruent with the ethical."[21] She does not explain the latter—"the ethical"—in the footnote where she hints at the difference between her own position and Honig's, but in the introduction to *The Challenge of Carl Schmitt,* she associates "ethics" with postpolitical Western liberalism, which imagines "that antagonisms have been eradicated" and has reached the state of "reflexive modernity" in which "ethics can now replace politics."[22] Mouffe's focus here appears to be on "'deliberative' or 'dialogic' forms of democracy" of the kind she attacks elsewhere—the work of John Rawls and Jürgen Habermas, for example.

But it seems that Honig can hardly be associated with that position—at least not the Honig I have discussed here (and, to be fair, the works of Honig that I have looked at all date from after Mouffe's *The Democratic Paradox,* in which the footnote about Honig can be found).[23] When Honig discusses the deliberative

17. In Chantal Mouffe, *Agonistics: Thinking the World Politically* (New York: Verso, 2013), 92.

18. Mouffe, *Democratic,* 101.

19. Mouffe, 102.

20. Mouffe, 103.

21. Mouffe, 107.

22. Chantal Mouffe, "Introduction," in *The Challenge of Carl Schmitt,* ed. Chantal Mouffe (New York: Verso, 1999), 2.

23. In fact, given Honig's own issues with the ethical as she lays them

model in her work on emergency politics, a model she associated with Elaine Scarry, she balances it out with Douglas Crimp's promiscuous politics in order to ultimately arrive at a legalist emergency politics that combines proceduralism with the transformation of procedure. This is perhaps not articulated in terms of antagonism, but it is definitely not deliberation's replacement of politics by ethics either. Certainly, when Honig aligns her position with "sovereignty," which after all is a term that is closer to Carl Schmitt than "liberalism" (which Mouffe claims for her cause), it seems that it is Honig (rather than Mouffe) who may be closer to Schmitt's antagonism. Neither of them, of course, would claim in any way to be Schmittians, not even left Schmittians. One might say that they approach the same issues from different sides: Mouffe wants to "politicize" liberalism, whereas Honig wants to liberalize "sovereignty." Both are important.

I bring up Mouffe's work, however, because she has been trying to consider art and aesthetics in this context—to think "agonistic politics" and "artistic practices" together. "Art has been subsumed by the aesthetics of biopolitical capitalism," she writes, "and autonomous production is no longer possible."[24] But the new system of labor—so-called post-Fordism—that (according to some) art has helped produce and into which art has been subsumed, also "opens the way for novel forms of social relations in which art and work exist in new configurations."[25] "The objective of artistic practices should be to foster the development of those social relations," she continues, "that are made possible by the transformation of the work process."[26] Art's task, then, is "the production of new subjectivities and the elaboration of new worlds."[27] She imagines art as

out at length, for example, in *Antigone, Interrupted,* Mouffe's charge seems rather outrageous in retrospect. See Bonnie Honig, *Antigone, Interrupted* (Cambridge: Cambridge University Press, 2013).

24. Mouffe, *Agonistics,* 86.

25. Mouffe, 87.

26. Mouffe, 87.

27. Mouffe, 87.

a "space of resistance," and artistic resistance as "agonistic interventions within the context of counter-hegemonic struggles"[28]—struggles against power politics that claim to exhaust the social field. Instead, something is always left over, and that excluded something asserts itself counterhegemonically against hegemonic power. Against neoliberalism's "there is no alternative" mantra, art asserts that *there is* an alternative—the alternative of what is excluded from any power formation. *No hegemony is total.*

As Mouffe explains, she does "not see the relation between art and politics in terms of two separately constituted fields, art on one side and politics on the other, between which a relation needs to be established. There is an aesthetic dimension in the political and there is a political dimension in art."[29] She doesn't distinguish between political and nonpolitical art but she thinks about possible forms of "critical art."[30] The state of things today is not "the kind of dispersion envisaged by some post-modernist thinkers. Nor are we faced with the kind of 'smooth' space envisaged by Deleuze and his followers. Public spaces are always striated and hegemonically structured."[31] This pretty much guarantees that there is an exclusion from where a counterhegemonic struggle can develop. What Mouffe calls "critical practices" cannot only deconstruct, de-identify, smoothen, et cetera. In addition, they must "bring about something positive"—and this is where her position is clearly beyond "postmodernism."

In that same text and elsewhere, Mouffe articulates this position in institutional terms. A leftist strategy that seeks to "ignore institutions and to occupy other spaces outside the institutional field" is in Mouffe's view "profoundly mistaken and clearly disempowering because it prevents us from recognizing the multiplicity of avenues that are open for political engagement."[32] Here

28. Mouffe, 88.
29. Mouffe, 91.
30. Mouffe, 91.
31. Mouffe, 91.
32. Mouffe, 100.

one sees, of course, her left liberalism in action. "To believe that existing institutions cannot become the terrain of contestation is to ignore the tensions that always exist within a given configuration of forces and the possibility of acting in a way that subverts their form of articulation."[33] "[W]e should discard the essentialist idea that some institutions are by essence destined to fulfill one immutable function."[34] In short, Mouffe is telling us to engage our institutions rather than withdraw from them.

To require a "total break with the existing state of affairs" is, in Mouffe's view, not political. She calls it a mistake. Artists today can no longer afford to take up that position, which elsewhere she understands to be a position of "exodus."[35] Here is how she summarizes that strategy:

> The traditional structures of power organized around the Nation State and representative democracy have today become irrelevant, and . . . they could eventually disappear. Hence the belief that the multitude can ignore the existing power structures and concentrate its efforts in constructing alternative social forms outside the State power network. Any collaboration with the traditional channels of politics like parties and trade unions are to be avoided. The majoritarian model of society, organized around a State, needs to be abandoned in favour of another model of organization presented as more universal. . . . political action should aim at withdrawing from existing institutions and freeing ourselves from all forms of belonging. Institutional attachments as *[sic]* deemed to constitute obstacles to the new non-representative forms of "absolute democracy" suitable for the self-organization of the multitude.[36]

This forecloses, Mouffe correctly notes, "an immanent critique of institutions, whose objective would be to transform them into a

33. Mouffe, 100.

34. Mouffe, 101.

35. Chantal Mouffe, "Institutions as Sites of Agonistic Intervention," in *Institutional Attitudes: Instituting Art in a Flat World,* ed. Pascal Gielen (Amsterdam: Valiz, 2013), 65.

36. Mouffe, 65–66.

terrain of contestation of the hegemonic order."[37] "Such a perspective," she writes with reference to the long quote above, "is, in my view, profoundly mistaken and clearly disempowering because it impedes us from recognizing the multiplicity of avenues that are opened for political engagement."[38] Instead, she wants to advocate "a strategy of 'engagement' with institutions."[39] This comes from the conviction that "things could always have been otherwise and every order is predicated on the exclusion of other possibilities"— the conviction of hegemony and the counterhegemonic struggle.

When critical practices "[desert] the institutional terrain" rather than "[engage] with it," they "do not contribute to the counterhegemonic struggle."[40] The latter "[fosters] dissent and [creates] a multiplicity of agonistic spaces where the dominant consensus is challenged and where new modes of identification are made available."[41] That seems particularly important in a time when many identities have been leveled by postmodernism or turned into mere sites for value extraction by neoliberalism. Rather than withdraw from the museum, then, critical artistic practice should engage with the museum and turn it into an agonistic space.

But to think in this way also has political parallels: "think for instance," Mouffe writes, "of the change of attitude of a part of the European left with respect to the institution of the welfare state."[42] "Similar considerations could be made towards the rule of the State which, after years of demonization, has been reevaluated during the 2008 financial crisis," presumably as a political agent that may be able to keep economic agents in check.[43] Unfortunately, things went the other way and the State ended up

37. Mouffe, 66.
38. Mouffe, 66.
39. Mouffe, 66.
40. Mouffe, 68.
41. Mouffe, 68.
42. Mouffe, 72.
43. Mouffe, 71.

bailing out the banks, realizing the fictitious capital that they had created (to put it in Anna Kornbluh's terms).[44] But, Mouffe notes, "things could have taken another direction" had "the power relations been different."[45] It seems the counterhegemonic struggle failed in this case. The conclusion is clear: "instead of celebrating the destruction of all institutions as a move towards liberation, the task for radical politics is to engage with them, developing their progressive potential and converting them into sites of opposition to the neoliberal market hegemony."[46] This goes for the art museum just as much as it goes for the welfare state or the State *tout court*.

At this point, I do not think we are too far removed from Honig's position. Mouffe's focus, of course, is on agonism (which has its roots in antagonism, and therefore in Schmitt); but this is an agonism that revitalizes liberalism, makes it political again. Honig doesn't name the engagement that Mouffe calls for "counterhegemonic," but she makes it part of a discourse on "popular sovereignty" (Mouffe doesn't use the latter term) and calls it (in her book on Antigone) "counter-sovereignty."[47] The latter she characterizes as bringing a break or interruption to "many theorists' fascination with rupture over the everyday, powerlessness over sovereignty, and heroic martyrdom over the seemingly dull work of maintenance, repair, and planning for possible futures."[48] This characterization further helps us understand the particular poli-

44. Anna Kornbluh, *Realizing Capital: Financial and Psychic Economies in Victorian Form* (New York: Fordham University Press, 2014).

45. Mouffe, "Institutions," 71.

46. Mouffe, 71.

47. Honig, *Antigone,* 2, 10, and elsewhere. Honig is not the only one to use this notion. See also Circe Sturm, "Reflections on the Anthropology of Sovereignty and Settler Colonialism: Lessons from Native North America," *Cultural Anthropology* 32, no. 3 (2017): 340–48 at 344. Sturm mentions "counterhegemony" (345) in this context as well, though without tracing the term back to Mouffe.

48. Honig, *Antigone,* 2.

tics of exceptionalism that she is interested in. She is defining an exceptionalism here—she is talking about a break or interruption with the notion of countersovereignty—but it is an exceptionalism of the everyday, maintenance, repair, planning (as in Elaine Scarry, for example). Honig puts the point very explicitly: "I go on to ask," she writes, "whether feminist and democratic theorists might rethink the rejection of sovereignty and consider devoting themselves instead to its cultivation."[49] Reading this position back into Mouffe, this would mean pushing Mouffe so far as to have her devote herself to the cultivation of new hegemonies through counterhegemonic politics.

My final example comes from a thinker that Honig critically engages with in this context,[50] Judith Butler. In her book *Notes Toward a Performative Theory of Assembly*, Butler is thinking through assemblies of bodies in the street as part of political protests—and as distinct from political speech, as she repeatedly puts it. Her focus is on "the people" and the institutions that claim to represent it.[51] Specifically, she is interested in the notion of "popular sovereignty" and its claim to represent (and enact) the power of the people.

In a chapter titled "We the People," Butler makes a claim that reminds one of Mouffe's work, namely that "no one popular assembly comes to represent the entirety of the people, but each positing of the people through assembly risks or invites a set of conflicts that, in turn, prompt a growing set of doubts about who the people really are."[52] This is Mouffe's issue of hegemony and the exclusions through which it operates, which trigger what Mouffe

49. Honig, 22.

50. The specific focus of that engagement is the issue of vulnerability, and more generally the relation between the ethical and the political, which is part of Mouffe's debate with Honig as well. I intend to come back to this at length in another context.

51. Judith Butler, *Notes Toward a Performative Theory of Assembly* (Cambridge, Mass.: Harvard University Press, 2015).

52. Butler, 155.

calls counterhegemony. There is, Butler suggests, "no assembly" that can truly claim to represent the people. Instead, there is always this "conflictual process" of constitution that raises the "epistemological" issue of who the people really are.[53]

Mouffe *also* articulates this as an *ontological* issue in the sense that, for her, the people are never united in the way that deliberative theories of democracy like those of Rawls or Habermas would want them to be.

If Butler is also interested in the speech act that constitutes the people, she is more interested in this context in the fact that assemblies already constitute themselves bodily, in the streets, before any words are uttered. So this is really much more the Arendtian position of bodies collectively appearing in space and making politics in this way. "Freedom of assembly" thus becomes, in her view, "a precondition of politics itself."[54] It is in this way that we arrive at the notion of "popular sovereignty" as distinct from state sovereignty in Butler's text.

What interests me about all of these examples is how they criticize sovereignty (and, in view of the project I am pursuing here, art's association with sovereignty) *not* from sovereignty's outside *but* from within—immanently, so to speak. Exceptionalism—and, by extension, sovereignty—is reclaimed from Schmittian discourses of sovereignty for democratic purposes. This is what I would characterize as these authors' *critique*. It is what separates these authors from one kind of exceptionalism and pushes them instead toward another—that of the everyday, maintenance, repair, planning, as Honig has it.[55]

53. Butler, 156.
54. Butler, 160.
55. In an interview with Diego Rossello, Honig has associated this other exceptionalism with "second wave feminism," which, she notes, "was particularly critical of the register of the extraordinary for being masculinist and heroic" (Diego Rossello, "Ordinary Emergences in Democratic Theory: An Interview with Bonnie Honig," *Philosophy Today* 59, no. 4 [2015]: 701).

Still, to what extent these discourses are actually different from Schmitt remains to be seen. Butler, for example, writes:

> I know that some people have come to consider "sovereignty" a bad word, one that associates politics with a singular subject and a form of executive power with territorial claims. Sometimes it is used as synonymous with mastery, and other times with subordination. Perhaps it carries other connotations, though, that we would not want to lose altogether.[56]

What are those connotations?

> One only needs to consider debates about native sovereignty in Canada or read the important work of J. Kēhaulani Kauanui on the paradoxes of Hawaiian sovereignty to see how crucial this notion can be for popular mobilizations. Sovereignty can be one way of describing acts of political self-determination, which is why popular movements of indigenous people struggling for sovereignty have become important ways to lay claim to space, to move freely, to express one's views, and to seek reparation and justice.[57]

Voting certainly does not exhaust the meaning of popular sovereignty—there is more to it. In fact, Butler uses the reference to voting to make the claim that what is called popular sovereignty "always remains nontransferable, marking the outside of the electoral process."[58] Popular sovereignty translates into electoral power, "but that is never a full or adequate translation":

> Something of popular sovereignty remains untranslatable, nontransferable, and even unsubstitutable, which is why it can both elect and dissolve regimes. As much as popular sovereignty legitimates parliamentary forms of power, it also retains the power to withdraw its support from those same forms when they prove to be illegitimate.[59]

There are echoes here of what Giorgio Agamben in his reading of Thomas Hobbes theorizes as the "dissolved multitude," which he

56. Butler, *Notes*, 160.
57. Butler, 160.
58. Butler, 162.
59. Butler, 162.

considers to be the true state of politics (as opposed to what he exposes to be the optical illusion of "sovereignty"; the people-king only exists in the moment of its institution—it crumbles into the dissolved multitude immediately afterward, a state of dissolution that might intensify into Civil War, which may lead—if the rebellious side is victorious—into a disunited multitude, which might elect a people-king again, and so on).[60]

However, given the fact that Butler is not a thinker of the multitude[61]—she in fact explicitly presents herself as a thinker of "the people," and therefore a thinker of sovereignty—it may be more correct to say that there are echoes here of Schmitt. In a discussion of Schmitt's book *Constitutional Theory*, Panu Minkkinen points out that, for Schmitt,

> constituent power . . . can never exhaust itself into the institutions it has constituted. . . . Or, in Schmitt's terms, a people "anterior to and above" the constitution, that is, the presupposed people behind every democracy, can never quite reduce itself into a people "within" the constitution, that is, into the people that the constitution identifies and recognizes as an institution. A constituent residue will, namely, always remains dormant in the institutions that the people may have constituted, and will re-emerge and activate itself if its political existence becomes threatened.[62]

For those who might object to the association with Schmitt, Minkkinen finds this position in the work of Bruce Ackerman and Jason Frank, both scholars whose work is clearly in the background of Butler's thought. This leads us back to Andreas Kalyvas's reading of Schmitt—specifically, the Schmitt of *Constitutional Theory*—as a democratic theorist.

Butler suggests that we may want to call the gap between popular sovereignty and electoral power "an 'anarchist' interval or a

60. Giorgio Agamben, *Stasis: Civil War as a Political Paradigm* (*Homo Sacer II*), trans. Nicholas Heron (Edinburgh: Edinburgh University Press, 2015).

61. See Butler, *Notes*, 135.

62. Minkkinen, "Rancière and Schmitt," 136.

permanent principle of revolution that resides within democratic orders, one that shows up more or less both at moments of founding and moments of dissolution, but is also operative in the freedom of assembly itself."[63] Schmitt would likely have shuddered at this, as he distinguishes anarchy from the state of exception. And it is perhaps on this anarchic count, to which I will return, that non-Schmittian exceptionalisms (and even unexceptionalisms, as I will argue later) truly set themselves apart from Schmitt.

In closing, let me consider how one could see some of these very issues mobilized in *Scaffold,* a work by Sam Durant.[64] Durant's work created controversy: installed in the Minneapolis Sculpture Garden of the Walker Art Center, the work had been taken down after protests by the Dakota people who had taken offense with the work. Built on a 1:1 scale, the work showed an immense gallows that was partly modeled after an immense gallows that had been used in the mid-nineteenth century to put thirty-eight Dakota men to death in Mankato, Minnesota. It had been, apparently, the largest mass execution in U.S. history. If Durant had rebuilt that massive technology of death here, exposing what Walter Benjamin already called "something rotten" in power, it was obviously not to celebrate that technology but to criticize it—and that appears to be how the work was received in Europe, where it had already been shown to great acclaim.

Not so in Minneapolis, where the artist's intention was perhaps not less clear, but where that intention's actualization through this particular work of art gave cause for offense. Perhaps even more disturbingly, Durant's attempt to criticize U.S. sovereign power, defined by the right to take life or let live (as Michel Foucault observed), was reappropriated by racist groups who showed up on the site of the protests by the Dakota people to defend their heritage through defending the sculpture. It was in view of this, and

63. Butler, *Notes,* 163.

64. In view of the controversy about *Scaffold,* there will be no reproductions of Sam Durant's work in this chapter.

after careful conversation with representatives of the Dakota people, that Durant ultimately decided with the Walker Art Center to take the sculpture down. Moreover, he signed over the copyright for the sculpture to the Dakota people, essentially agreeing never to use the sculpture again. For a while, the fate of the sculpture's materials remained unclear. It was said that the materials would be burnt. Ultimately, because of the role of fire for the Dakota people, it was decided that the materials would be buried at an undisclosed location. This act resonates not only with Antigone, a figure who is central to both Honig and Butler's work, but also with the execution that Durant's work evoked, for at that time the Dakota people had not been allowed to bury their dead.

Some thought Durant was too quick to give in to the Dakota people and should not have accepted what they considered their "censorship." But Durant himself did not feel that way. He appreciated the Dakota people's concerns, and acknowledged that installing the work in Minneapolis, and not consulting with the Dakota people for its installation or even its design (which, after all, uncovered a very painful part of their history), was a mistake, a failure of the artist-as-a-white-man to listen to the concerns of "the other." Durant, who usually makes provocative, research-based work that engages racial issues in the United States, had evidently decided to memorialize a painful part of U.S. and indigenous history through a monumental work that he considered an abstract reminder of sovereignty's power to take life.[65] But he had perhaps not sufficiently considered how his decision to rebuild a gallows at the 1:1 scale also risked monumentalizing that painful part of history and how the work of art risked becoming complicit with the very sovereignty it contested. There was a way, in other words, in which

65. I am relying here on statements made by Durant during various public appearances at the California Institute of the Arts during Fall 2017 to discuss his work, and the controversy it created, with CalArts students. I attended these discussions.

Durant somehow assumed an even greater sovereignty for art,[66] as if art would somehow—and in an exceptional way—be able to stand outside of history, in a transcendent realm of abstraction, as art separate from the world.

This illusionary conception of art was contested, however, from a perhaps surprising corner: from the site of a third sovereignty, the indigenous sovereignty of the Dakota people, who took offense with Durant's work and used their indigenous sovereignty as the ground to make that offense explicit. They claimed the emergency to propose a democratic, agonistic countersovereignty (thus pluralizing sovereignty itself). Everything here takes place within the realm of sovereignty. And it yielded, I would argue, a *critical sovereignty* (as Joanne Barker, editor of a book on sovereignty and indigenous gender, sexuality, and feminist studies puts it)[67] rather than *sovereignty's outside.* That was *Scaffold's critique.*

I am pretty sure *Scaffold* was meant to be critical of sovereignty, but I do not know if Durant had intended with the work a critique in the sense that I have used the term here. If critique was his goal, then I think rebuilding the scaffold on the 1:1 scale in an attempt to reclaim death-wielding technologies of sovereignty for "other uses" was ill-conceived. My suspicion is, however, that what Durant intended was not critique but mere criticism. I'm suspicious about whether he thinks *any* aspects of sovereignty can be redeemed. The irony is, of course, that with his grand, critical, artistic gesture he seemed to reinstate precisely—presumably against his own intention—the violent power of sovereignty, this time in the form of art. And *because it was art,* he thought, *surely everyone would realize that it was outside of the problematic sovereignty that he sought to contest.*

66. It is worth pointing out that Durant does this through the deceivingly unexceptionalizing gesture of the copy. I will return to this at length in the next chapter.

67. Joanne Barker, ed., *Critically Sovereign: Indigenous Gender, Sexuality, and Feminist Studies* (Durham, N.C.: Duke University Press, 2017).

While political sovereignty and sovereignty in the form of art *are* of course *different,* this was nevertheless proven to be a naïve assumption. What happened to Durant's work laid bare beyond this obvious difference art's imbrication in, and even *complicity with,* sovereignty. It exposes, furthermore, that the idea that art somehow exists separately from the problems of sovereignty that Durant wanted to contest is itself a sovereign illusion that repeats the very problems it seeks to contest. Now, what's interesting about all of this is that this does *not* get exposed from an intensification of Durant's intention and this naïve assumption about art. It does *not* get exposed from an artwork that manages to be separate from sovereignty, as Durant had perhaps assumed about his own work. Instead, this gets laid bare through *another* sovereign intervention, critical this time, from the Dakota people, who both contest the sovereignty of art and the U.S. sovereignty from which they have suffered and continue to suffer. It shouldn't come as a surprise at this point that indigenous sovereignty is something that both Honig and Butler are very interested in and write about.[68]

One exceptionalism is leveled against another here and thus something begins to happen to sovereignty and *Scaffold*'s complicity with it—something that can lead us to question certain Schmittian elements in exceptionalist accounts of art at large.

In other words, Durant actually learns something here, in the middle of his perhaps naïve criticism of sovereignty (and unwitting reinforcement of a sovereign theory and practice of art), about how sovereignty can be critically useful. Far from leading to the rejection of sovereignty, then, *Scaffold* leads one back into it, laying bare sovereignty's critical and democratic potential, against the fascist instances of sovereign violence that I have mentioned—but also outside of naïve theories of art as exceptional that risk perpetuating the very problems of sovereignty that *Scaffold* sought to attack.

68. See, for example, Bonnie Honig, *Public Things: Democracy in Disrepair* (New York: Fordham University Press, 2017).

Some may be surprised by my use of the term "sovereignty" rather than "autonomy" in my discussion of Durant's work. I opted for the term "sovereignty," of course, in view of the fact that Durant's work shows a technology of sovereignty. But by using sovereignty rather than autonomy in this context, I also seek to contest the ways in which an artwork's autonomy risks taking on a sovereign dimension—the way in which autonomy risks becoming confused with sovereignty. This is a subtheme that was launched at the end of the previous chapter, when I noted the glossing of autonomy as the idea that "artistic genius is sovereign." Such an identification of autonomy with sovereignty is problematic, first of all because it defuses autonomy's critical potential in relation to sovereignty. Here, however, I have approached that issue from the other side, by drawing out the ways in which sovereignty can also be emancipatory precisely by how it exceeds autonomy. This may be one other reason why the term "sovereignty" rather than "autonomy" *should* be the term of operation in this context.[69]

Let me conclude my reading of *Scaffold,* then, by emphasizing that there is nothing simple about any of this: indeed, to label the actions of the Dakota people as "sovereign" means to inscribe them within a political history of Western power that they may very well want to refuse. It risks perpetuating a logic of internal colonization through Georg Wilhelm Friedrich Hegel's celebrated but problematic master/slave dialectic, in which true self-consciousness is reached through a process of recognition. The anthropologist Elizabeth Povinelli has pointed out the "cunning" of such a process when it comes to inscribing the "other" within the master-narrative of the "self," given that recognition always takes place in the master's terms (in this case, "sovereignty")—even if it is ultimately the slave who is the hero of Hegel's dialec-

69. Seth Anziska has emphasized the importance of this distinction in the related context of the Israel–Palestine conflict. See Seth Anziska, "Autonomy as State Prevention: The Palestinian Question after Camp David, 1979–1982," *Humanity* 8, no. 2 (2017): 287–310.

tic.[70] But others have taken a more pragmatic approach when it comes to Indigenous politics and have argued that such recognition is necessary to be politically effective. In addition, to insist on one's sovereignty and to make claims from that ground means to refuse being labeled a "minority group."[71] Durant's work, situated in the context of these specific debates as well as broader debates about sovereignty today, can help one navigate some of these complexities.

70. Elizabeth Povinelli, *The Cunning of Recognition: Indigenous Alterities and the Making of Australian Multiculturalism* (Durham, N.C.: Duke University Press, 2002).

71. See, for example, Joanne Barker, "For Whom Sovereignty Matters," in *Sovereignty Matters: Locations of Contestation and Possibility in Indigenous Struggles for Self-Determination*, ed. Joanne Barker, 1–31 (Lincoln: University of Nebraska Press, 2005), 18.

3. Against Monarchical Art: Alex Robbins's "Complements"

All significant concepts of the modern theory of the state are residual monarchical concepts.

—STATHIS GOURGOURIS, *The Perils of the One*[1]

I SHOULD BE VERY clear then about my target, which is not exceptionalism at large but a specific kind of exceptionalism that has often been tied to Schmitt. My suggestion is, however, that such exceptionalism is widespread in the art world, and is implicated in the art world's economic and political order. Indeed, it is profoundly rooted in Western thought.

In his book *Shanzhai: Deconstruction in Chinese,* Byung-Chul Han summarizes such a thought and provides a countermodel to it.[2] Starting from Hegel's frustration with the Buddhist notion of "emptiness," Han points out that "emptiness in Chinese Buddhism means the negativity of decreation (*Ent-Schöpfung*) and absence (*Abwesen*). It empties out Being (*Sein*)" (2). In contrast to Western ideas of "essence," ideas that a philosopher like Jacques Derrida has done much to unwork, "Chinese philosophy is deconstructivist from the outset, to the extent that it breaks radically with

1. I would like to thank Stathis Gourgouris for allowing me to quote from his manuscript, *The Perils of the One: Lessons in Secular Criticism II.*

2. Byung-Chul Han, *Shanzhai: Deconstruction in Chinese,* trans. Philippa Hurd (Cambridge, Mass.: MIT Press, 2017). Further page citations appear in the text.

Being and essence" (2).[3] This orientation may have something to do with "the Chinese awareness of time and history" (3). "For example," Han writes, "transformation takes place not as a series of events or eruptions, but discreetly, imperceptibly, and continually ... Ruptures or revolutions ... are alien to the Chinese awareness of time." Chinese thought "does not recognize the kind of identity that is based on a unique event" (3).

If the philosophical stakes of this are clear—for ontology, for a philosophy of time—Han also draws out its aesthetic consequences. "In classical Chinese," Han writes, "the original is called *zhen ji* ... Literally this means 'the authentic trace'" (10). In Chinese thought, in other words, the original is always already a trace, and "the trace always lets the artwork *differ from itself.*" "Its *difference to itself* does not allow the artwork to come to a standstill whereby it could achieve its final shape." If Plato banned mimesis from his ideal Republic, this was because Western thought has an entirely different view of the original as what Han calls "monomorphic presence," "monoeides" (in Greek, with "eidos" marking the Platonic idea or form) (11). But "the basic figure in Chinese thought is not the monomorphic, unique *Being* but the multiform, multilayered *process*" (13). Chinese thought breaks out of a *monological* notion of art.

As a consequence, both individual and collective works are open to transformation. Han considers for example how in ancient or classical Chinese art often a large part of the painting is left open so that collectors can add their seal stamps to the painting, situating the painting as trace in a conversation with others and turning it into an "open ... field of dialogue" (34). Han analyses as

3. Han's phrasing "deconstructivist from the outset" might appear odd given that it projects back into the outset a term, "deconstruction," that was only developed later. However, given Derrida's claim that one does not deconstruct but merely teases out a process of deconstruction that is always already at work, such a retro-projection might be admissible. If anything, it does reveal Han's audience, as he appears to be using the term to make Chinese thought accessible to the Western philosophical reader, who has come closest to it through deconstruction.

the opposite of this Jan van Eyck's "The Arnolfini Portrait," which, with its author's name and image firmly inscribed at the center of the painting, clearly "points out that the named person is also the creator of the artwork" (52). This is unthinkable in the ancient or classical Chinese work of art, which is always subject to transformation and whose authorship is much less clearly determinable. "For example, the oeuvre of the famous master Dong Yuan looks different in the Ming dynasty from how it looked during the Song dynasty, with even forgeries or replicas defining a master's image" As Han points out, there is a temporal inversion that occurs here: "The subsequent or retrospective defines the origin . . . The oeuvre is a large lacuna or construction site that is always filling up with new contents and new pictures." "We might also say: the greater a master, the emptier his oeuvre" (13).

Some of this, Han points out, can be found in the work of Theodor Adorno as well; but whereas Adorno insists on the artwork's "inexhaustible fullness and unfathomable depth," "the Chinese artwork is *empty* and *flat*. It is without soul and truth" (14). To learn to become an artist, one must copy the works of the masters. If one has become such a good student that one's copies are indistinguishable from the master's works, if one has become the master's equal, this is proof of one's own mastership—there is nothing negative associated with that. "Creation," Han points out, "is not a sudden event, but a slow process, one that demands a long and intense engagement with what has been, in order to create from it" (16). The consequences are, from the Western point of view, enormous: "If a forger borrows a painting from a collector, and when returning it hands over a copy unnoticed instead of the original, this is not considered a deception but an act of fairness" (16). Or, as Han concludes: "This is an extraordinary practice from ancient China that would put an end to today's art speculation" (23).[4] If "truth" in the West operates through "exclusion"

4. Perhaps Han is a bit naïve here. It is more likely that Chinese artists

and "transcendence," "Chinese culture uses a different technique that operates using inclusion and immanence" (29). One can only imagine this, he writes, "in a culture that is not committed to revolutionary ruptures and discontinuities, but to continuities and quiet transformations, not to Being and essence, but to process and change" (31). In other words: one can only imagine it outside of aesthetic exceptionalism.

As Han points out, there is something "organicist" to this, since it is "nature" that "provides the model": "The organism also renews itself through continual cell replacement" (62). This applies to the ancient or classical Chinese approach to the master's oeuvre or the art collection, but it is perhaps more clear in the case of a building restoration, where over time all of the parts of the building are replaced, but it is supposedly still the same building (the well-known metaphor of the ship, whose different parts are gradually all replaced *en route,* also comes up in Han's book[5]). "Identity and renewal are not mutually exclusive" (62), Han writes. In such an approach, modularity is crucial, since it enables reproducibility, which is this approach's central value. This marks the end of the idea of "genius" (68), as Han points out, an idea that came into being with Leonardo da Vinci and is a cornerstone of Kant's aesthetics.[6] Ultimately, this amounts to an aesthetics of de-creation or *Ent-schöpfung*: the unworking of the figure of the creator who, as both god and the artist, is theo-

and art dealers would figure out how to turn this difference into a financial advantage and that the global art market would become Westernized in that sense.

5. See Han, 83n3. With this well-known metaphor of the ship being rebuilt while at sea, the risk of conservatism opens up: the metaphor can indeed easily be used to counter proposals of radical change, and indeed change *tout court.* While it will be clear that I am not arguing against change here—the previous chapter was precisely about saving change from discourses of exceptionalism—it is true that through my criticism of exceptionalism I am countering "radicality" in the sense of a total rupture.

6. See Han, 84n11.

logical and aesthetic exceptionalism's central figure, with all of its political consequences.[7]

Han is certainly not the only thinker to present Chinese thought in this way. Although philosopher François Jullien's entire oeuvre—the divergence it stages between Chinese thought and Western philosophy—applies here, it is perhaps the chapter "Mythology of the Event" from his book *The Silent Transformations* that is the most *à propos*.[8] Jullien takes on there precisely the Western philosophical notion of the event as a representation of "exceptional . . . irruption [and] upheaval" (116), arguing precisely that it is a "fictive or mythological representation" (117). Instead, and coming from Chinese thought, Jullien theorizes the event as "a matter of emergence" (126). Where Western philosophy finds the "incomparable, non-integratable event" (122), Chinese thought offers "a silent maturation of the negative" (121), which, when "conditions are ripe for it" (119), leads the event to emerge.

Singling out Alain Badiou's thought as an example of how "the event still continues to fertilize philosophy today" (122), Jullien considers the "characteristic of Chinese thought" to be "precisely to dissolve the event" (126). Thus, the event enters into an "equality with others, without privileging one moment or excepting it in relation to all moments" (126–27). Chinese thought, as he puts it,

7. The notion of "use," and how "use" unexceptionalizes whatever it uses, seems relevant in this context. If "unusability" is a key category of art for Kant (as for example Davide Panagia has discussed: *Ten Theses for an Aesthetics of Politics* [Minneapolis: University of Minnesota Press, 2016]), it should be reread as a trait of aesthetic exceptionalism that "use" seeks to undo. Giorgio Agamben, to whom I will turn in the next two chapters of this book, has pursued such a project throughout his oeuvre, but perhaps in particular in his text "In Praise of Profanation." Another name for unexceptional art could very well be profane art. See Giorgio Agamben, "In Praise of Profanation," in *Profanations,* trans. Jeff Fort, 73–92 (New York: Zone Books, 2007).

8. François Jullien, *The Silent Transformations,* trans. Krzysztof Fijalkowski and Michael Richardson (London: Seagull Books, 2011), 116–35. Page citations will appear in the text.

"absorb[s] the prestige of the event" (127). Recalling Wolin's criticism of Schmitt's politics as being too focused on the aesthetic of shock, it's worth noting that in Jullien's Chinese thought the "brutality of the 'event' [only] amazes us, because we have not known how to distinguish the silent transformation which has imperceptibly led to it" (129–30). Chinese thought does not know rupture. If Jullien mobilizes such thought here, it is against what he characterizes as the "reign," the "dictatorship" even (130), of the event, which has discreetly infiltrated all communication. If Han's book risks, at times, to look a little thin, it is Jullien's deep knowledge of Chinese thought that can be brought in to back up the core of Han's shanzhai project.

Nevertheless, some questions remain. It would be interesting to consider, first of all, the *historical location* of Han's claims and ask whether they also apply to contemporary Chinese art. Most likely, it would appear that contemporary Chinese art has been fully Westernized, i.e., fully folded within the logic of aesthetic exceptionalism, which makes sense from a financial point of view.

Second, one should ask whether Western aesthetics has *always* corresponded to the image that Han sketches of it here, or whether that image is historically located. When it comes to the issue of reproducibility, for example, it seems dubious that it can be used transhistorically to oppose China and the West. In some of his work on aesthetics, the French philosopher Bernard Stiegler recalls how in paintings representing the Louvre just a few years after it opened, "one can see that the visitors, who are most definitely almost all artists, mostly reproduce paintings there."[9] At least at that time—the museum opened in 1793—copying appears to have been crucial to artistic production. For artists and art *connaisseurs* at the time, it was "impossible to talk about a canvas that one has not copied."[10] In other words, it is through copying that one gets to have intimate knowledge of a painting.

9. Bernard Stiegler, "The Proletarianization of Sensibility," trans. Arne De Boever, *boundary 2* 44, no. 1 (2017): 5–18 at 6.

10. Stiegler, 6.

Now, when Stiegler considers the shift in Marcel Duchamp's work from the "wet" painting *Nude Descending a Staircase, No. 2* from 1912 and the infamous *Fountain* (from 1917),[11] he is interested in a shift that takes place in between these two works that concerns the status of copying. In between these works, copying becomes *mechanized* and in Stiegler's view "the readymade is born from the serialized production for mass markets."[12] In other words, it's not so much copying or reproducibility that are the issue here, but *mechanical* reproducibility, and this is why Walter Benjamin's celebrated text about "The Work of Art in the Era of Mechanical Reproducibility" is an important resource for Stiegler. Today, with digitization, we are living through a new era of the development that Benjamin was already tracing, and Stiegler is interested in considering the aesthetic consequences of the latter. He marks those as a proletarianization: a loss of the knowledge of (how to copy) a work of art.

There is no doubt that *today*, copying has largely disappeared from the museum—even if, occasionally, one will find an artist or a group of art students in a museum gallery copying a famous canvas and even if postcard copies of works will be on sale in the museum gift shop. This may have to be tied to the disappearance not so much of the practice of copying but the practice of drawing, partly as a consequence of how art has developed. It does not make a whole lot of sense to take a group of art students to the museum and ask them to copy a Jackson Pollock.[13] Overall though, Han seems correct in his analysis that copying, in the Western art world, has accrued a bad rap and is associated with plagiarism and forgery. The museum is not nearly as open to the copy and to copying as it seems to have been in the late eighteenth century—the institutionalization of artists like Andy Warhol, who turned the

11. Duchamp of course has to be a lodestar in any thinking about unexceptional art, and I will return to his work on multiple counts below.

12. Stiegler, 5.

13. I would like to thank Alex Robbins for these points about drawing.

copy into a part of their practice, notwithstanding. In this light, "the use of the photocopier as a creative tool" as it was explored in the "Experiments in Electrostatics" exhibition at the Whitney Museum in New York can partly be read as a reaction against these developments.[14] That is so even if this exhibition deals with mechanical reproduction rather than craft-based copying. It is not insignificant, given Stiegler's argument, that this exhibition stopped "at the dawn of the digital era in the 1980s." By and large, however, there appears to have been a progressive institutionalization of art as Art—art with a capital *A*—that is original and authentic, separate from the "bad" copy (small, very small *c*). Another indication of this process might be that *if* copying is still allowed in the museum today, *only* dry mediums are allowed. Presumably wet paint is banned because of the risk of interference with the original.[15]

Strangely, this progression seems to have been set in motion precisely at a time when, as Stiegler in another lecture on aesthetics lays bare, commoners struggled to be recognized as art ama-

14. The quoted text is lifted from the exhibition's webpage: https://whitney.org/Exhibitions/ExperimentsInElectrostatics. I would like to thank Martin Woessner for bringing this exhibition to my attention, and for underlining the importance of Warhol in this context.

15. Think here of Duchamp's little-known work *Pharmacie,* which "consists of a mass-produced poster-sized print of a 'winter landscape,' available to painting novices as an example of a composition they might attempt." Duchamp's "readymade 'intervention'" was to "sign the piece . . . but he also adds a tiny dab of red and green paint to the landscape's far horizon" (Stephen Barker, "Unwork and the Duchampian Contemporary," *boundary 2* 44, no. 1 [2017]: 53–78 at 63). Duchamp quite literally uses wet paint to interfere—but within the mass-produced print. The mass-produced print is supposed to be the original, which painting novices are supposed to copy—but of course the original is already a copy. Duchamp intervenes in this chain of copies by adding original elements to the original copy. This doesn't quite render the original copy into an original, but it does intensify its exceptionalist element. Some confusion is produced by Duchamp's project, similar to the confusion produced by the signature "R. Mutt" that marks *Fountain*: does it exceptionalize or unexceptionalize? I will return to this later.

teurs against "the practice of the Amateur [amateur with capital *A*], embodied by persons of noble rank, supposedly endowed with what the ancien régime called the 'natural taste' proper to 'persons of rank.'"[16] As Stiegler puts it in more political terms, it is "monarchical taste" that is being targeted here, and being democratized from the king and the nobility—only those of rank can have taste—to the commoners. A commoner too could copy, and it is because of one's copying skill that one becomes an art amateur—not just because of one's rank.

Perhaps then the three developments need to be read together, in the sense that (1) the democratic birth of the amateur (small *a*) and (2) their simultaneous proletarianization lead to (3) a kind of monarchization of Art (capital *A*), because with the proletarianization of the amateur, copying disappeared from the museum, and monarchical Art was instituted. What looked like a democratic moment on the side of the spectator was actually a profoundly undemocratic moment on the side of art and the art institution, as marked by the disappearance of the copy. Adam Bosse's *Leviathan,* the frontispiece of Thomas Hobbes's celebrated work on sovereignty, can thus come to stand in for the work of Art at large. It is those traces of (1) the democratization of the art amateur plus (2) their proletarianization and (3) the monarchization of Art that one confronts in a discussion of aesthetic exceptionalism.

I want to consider in this context an exhibition by Alex Robbins titled "Complements," which was up at the Monte Vista Projects artist-run space in Los Angeles in Spring 2018. Before moving to Los Angeles a few years prior, Robbins was based in London, where he showed sculptural work. At Monte Vista, Robbins showed six paintings that would probably strike *connaisseurs* of art history as familiar: indeed, the statement accompanying the show reveals that the paintings are elaborately crafted copies, mostly at dif-

16. Bernard Stiegler, "The Quarrel of the Amateurs," trans. Robert Hughes, *boundary 2* 44, no. 1 (2017): 35–52 at 38.

ferent scales and most importantly in inverse colors of celebrated works by the early modernists Christian Rohlfs, Pierre August Renoir, Walter Sickert,[17] as well as Willem de Kooning. The show also includes a copy, at a different scale but in noninverted colors, of John Singer Sargent's *Mrs. Carl Meyer and Her Children*.

Robbins had shown other such inverted paintings before, as part of two solo exhibitions: "Sculptures and Compliments" (at Tyler Wood Gallery in San Francisco) and "Hysteron Proteron" (at Commonwealth and Council in Los Angeles). One can get a sense of the effect of Robbins's inversions by considering a painting not included at Monte Vista, Pierre Bonnard's *Nu rose à la baignoire*: if the original bathes in pink, here blue becomes the dominant color.

The Sargent stood out in the Monte Vista exhibition since unlike the other paintings it did not come in the inverted colors. Yet it was mounted on a wall with inverted paintings. Interested in the artist's use of color as a highly prized aspect of their style, one that depends on its reception by the retina of the spectator's eye, which in fact produces an afterimage of the perceived painting in the inverted colors, Robbins seeks to capture here precisely that afterimage, thus in fact producing as an afterimage of the spectator's retina the work in the original colors. If the Sargent, which portrays subjects looking out at the viewer, may at first strike one as banal—or "inane," as the statement for "Complements" has it—the gazes of Mrs. Carl Meyer and her children become loaded in the context of this series with a kind of conceptual excess that leads one to suspect one may be dealing with conceptual works here rather than with paintings. It is not entirely clear that the works

17. The Sickert was the only painting rendered at the 1:1 scale. As the artist explains in private correspondence: "That is because he had a lot of exposed canvas and dry brushwork in which the weave of the canvas is evident. Replicating that weave, which is a central aspect of the feel of the painting, at a different scale or even at the same scale is very difficult, if not impossible to do. I mounted canvas on board at the same scale so I could have the same effect."

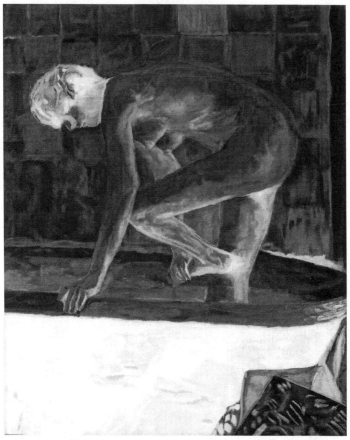

Alex Robbins, *Nu rose à la baignoire.*

that were on show at Monte Vista can be called "paintings"—in spite of all the evidence to the contrary.

Robbins's focus on the retina in his understanding of his conceptual work is particularly interesting given Marcel Duchamp's notion of the "post-retinal" or "non-retinal":

Since Courbet [Duchamp comments in an interview with Pierre Cabane], it's been believed that painting is addressed to the retina. That was everyone's error. The retinal shudder! Before, painting had other functions: it could be religious, philosophical, moral. If I had a chance to take an anti-retinal attitude, it unfortunately hasn't changed much; our whole century is completely retinal, except for the Surrealists, and still they didn't go so far![18]

As the scholar Stephen Barker explains, Duchamp has in mind in particular works like *Fountain,* which he opposed to painting, associated with the retinal. Duchamp has in mind in particular the readymade, like his work *Bicycle Wheel,* which was, Barker writes, "astonishingly, not shown publicly until 1951, and even then, typically sotto voce, as a 'replica of the lost original,' a wonderfully enigmatic description for an object that 'originally' claimed to be anything but (an) original [it was created "for Duchamp's own amusement," as Barker points out, as "a kind of mechanical toy"], let alone a work of art."[19] One finds here not only the non-retinal, but the non-retinal in association with the replica or the copy, with the absence of the original.

Robbins seems to want to take up these conceptual issues associated by Duchamp with the readymade but *within* the realm of painting, outside of the opposition between the readymade and painting, and the non-retinal and the retinal, that Duchamp sets up. Such an opposition, Robbins proposes, is already false, and in fact the retinal *itself* already includes the deconstruction of the original that Duchamp associates with the non-retinal readymade.

Also worth noting in view of Robbins's focus on the afterimage, the image that arrives with a kind of delay, is Duchamp's insistence

18. Duchamp, qtd. Cabanne, qtd. Barker, "Unwork," 58. Duchamp's position needs to be inscribed in the broader history of French critiques of ocular-centrism as documented in Martin Jay, *Downcast Eyes: The Denigration of Vision in Twentieth-Century French Thought* (Berkeley: University of California Press, 1993). I would like to thank Martin Woessner for this reference.

19. Barker, "Unwork," 59.

on the fact that the non-retinal readymade arrives as "hiatus, pause, suspension."[20] As Barker reports, "this is how, after the epoch of the readymade, Duchamp thought of the 'Bachelor Machine' of *Large Glass*: he instructed that it not be called a 'picture' but instead to 'use 'delay' instead of picture or painting: picture on glass becomes delay in glass [*retard en verre*]," and he adds that "there is no better example" of this than *Fountain,* which arrived as a work of art precisely through such a delay.[21] In spite of being retinal, Robbins's work, too, operates through a delay, conceptually rewrites well-known retinal art as delay, thereby projecting the readymade into the painting and deconstructing all of the oppositions that Duchamp distinguishes.

Robbins works primarily with color to undermine the distinction between the original and the copy and inverts the way in which this distinction is materialized through the human retina and the afterimage that it produces of a work of art that it perceives. Perhaps for reasons of copyright, Robbins also adjusts the scale (again, with one exception). But the works are in all other respects exact copies, executed with the kind of obsessiveness that characterizes Robbins's sculptural works as well. I am thinking, for example, of the sculpted books (for example, Karl Marx's *Wages, Price, and Profit* which was part of the "Primer III" show at the Luckman Fine Arts Complex in Los Angeles; or *Capitalism for Beginners,* from "2010.2 Alex Robbins," MOT International, London) through which Robbins sought to execute a kind of reverse move: the fetishization—as a hand-carved block of wood, silkscreened and painted as a meticulous recreation of a worn book cover—of a mass-product object that is then put back on the market (in this case, the art market, which would attach a much higher prize to the sculpted book than an actual book would ever fetch—even if the sculpted book is obviously not legible, is not a book and has thus been stripped of its use as a book).

20. Barker, 66.
21. Barker, 66.

Alex Robbins, *Wages, Price and Profit.*

It is probably not irrelevant that, again with the exception of the Sargent, all of the paintings that Robbins chose to copy are nudes. By inscribing "Complements" within the history of the nude, a history to which I will come back at some length in the section of this book titled "Complement," Robbins draws attention to the ways in which nudity is caught up in a relation with clothing (the subjects in the Sargent painting are, appropriately, clothed), which arguably mirrors the relation between the original (the nude) and the copy (clothing), with "Complements" producing an inversion in this context as well. By inverting the colors, Robbins's nudes seem strangely clothed; by contrast, the subjects in the Sargent—and in particular, the mother—appear naked, a nudity that is reinforced by Mrs. Carl Meyer's pink, flesh-colored clothing. Robbins does not quite do away with the dialectic between nudity and clothing, and original and copy, but by inverting it he does open up a pathway in that direction.

Inevitably, Robbins's "Complements" opens up a discussion about plagiarism—is changing scale and color enough to avoid the charge?—and forgery. Robbins has likely chosen the title "Complements" because it names his use of complementary colors to execute the paintings on display. But the complement can also be read in relation to what Jacques Derrida in his reading of Rousseau already referred to as "that dangerous supplement,"[22] the thing that is added to something in order to make it complete. As such, the supplement is dangerous, because it draws the very completeness of that something into question, thus destabilizing, for example, notions of presence and originality. It is also dangerous because as an exterior addition, it risks to entirely replace that which it supplements. The complement, which according to Derrida (who consults the Robert's *French Dictionary* for this) is distinct from the supplement because it is an internal—rather than external—addition.[23] If the complement as such does not quite pose the threat of replacement, then, it still carries some of that danger that Derrida—via Rousseau—identifies. In this view, one could locate a Derridean deconstruction in Robbins's practice, one that undermines—like Derridean deconstruction—key notions in the Western philosophical tradition.

Placed within the context of the art gallery, however, one senses that Robbins's "dangerous complements," if I can now call them that, also go to the heart of how those spaces—and by extension, the art world at large—are organized. "Complements" targets, specifically, what I have been calling aesthetic exceptionalism by bringing what is obviously a copy *within* the space of the gallery. There is, of course, the question of the aesthetic value of "Complements": after all, its subject matter and composition, and to a certain extent its color (even if the works are in inverted colors, those colors are still determined by the colors in the original), have been copied

22. Jacques Derrida, *Of Grammatology,* trans. Gayatri Chakravorty Spivak (Baltimore: The Johns Hopkins University Press, 1997), 141–64.
 23. Derrida, 145.

from already existing works. But when placed on the gallery wall, the work *also* opens up an economic question, for the works are for sale, and they are being sold by the artist Alex Robbins—with no royalties for the artists whose work he has copied.

Interestingly, none of the paintings are signed "Alex Robbins." Instead, Robbins has meticulously reproduced the signature of the artists who made the original works, in its inverted color. Something interesting happens here to the signature, which goes from being a signature to being something painted, like everything else in the painting. The signature loses its exceptional force as an authenticating element[24] and becomes merely a part of the painting's composition, an element that exists at the same level as the other elements in the painting. This is not a signature, but just painting. Robbins does not add his own signature: the work in the inverted colors, the copy, is not reappropriated through a new authentication, even if of course putting the work on display as part of a gallery show by Alex Robbins provides this authentication *in the margin* of the actual works.[25] "Complements" thus undermines, in addition to its troubling the distinction between original and copy and nudity and clothing, the notion of the art-

24. This is a theological reading of the signature, in the sense that, as such, the signature is the result of the secularization of God-the-creator into the artist. There are other theological approaches to the signature: artists might also erase their authorship, avoid any attempt at authentication, from a theological point of view, out of deference toward the Creator. Both of these positions are ultimately exceptionalist, even if they locate that exceptionalism differently. The supposedly secular figure of the artist is revealed then to be no more than a theological figure in disguise. The same is obviously true for many other supposedly secular concepts, as Schmitt (among others) enabled us to see.

25. In addition, Robbins also puts his initials and a date on the back of the works. In private correspondence, he acknowledges that he has always had trouble signing his own work and in fact signs the work only as he does his children's clothing—so that in case the clothing gets lost, the finder will know where to return it. There is a trace of "origin" here, but it is very weak indeed, to gain force only in the exceptional case of a loss.

ist, whose person and signature authenticate the originality of the work. Moreover, "Complements" resists reproducing that logic of authentication by leaving Robbins's own signature out.

On this count too, one senses an echo of Duchamp, who "signed" the urinal "R. Mutt 1917," supposedly to make the piece "more impersonal," as he himself argued—but Barker points out there is little logic to this, even if the signature "R. Mutt" evokes the German word for "poverty," *Armut*, and thus appears to go precisely against a speculative art market that is rooted in authentication of the artwork through the artist's signature.[26] The gesture of the signature needs to be read instead as one of appropriation, especially in view of the fact that it was most likely not Duchamp who proposed the urinal as art but one of his friends, "une de mes amies," as he reports in a letter to his sister.[27] By acknowledging as much to his sister, however, Duchamp *disavows* having had any role in the arrival of the urinal in the art world, a disavowal that is much more effective—even if it arrives in the privacy of a family letter—than his proprietary addition of the signature "R. Mutt."

As conceptual work, Robbins's ingenuous inversion of the colors and change of scale likely adds enough of a difference to his repetition to set these works aside as "original" works. But one should note in this context that Robbins's work was shown at Monte Vista, an artist-run space where artists receive 100 percent of their sales (as opposed to the 50 percent cut that is the industry standard). Here then we get yet another inversion, a glimpse of an art world in which the copy actually yields the artist more than the original. This can be an indication of how Robbins's work risks upsetting the art market, where originality is the key component

26. Barker, "Unwork," 64. The tie to poverty would open up a pathway to the negotiation of various exceptionalisms in Hito Steyerl's theorization of "The Poor Image." I have offered such a discussion elsewhere: Arne De Boever, *Plastic Sovereignties: Agamben and the Politics of Aesthetics* (Edinburgh: Edinburgh University Press, 2016), 290–337.

27. Duchamp, qtd. in Barker, "Unwork," 65.

of price. Everything here, all the way up to the space where the work is shown, contributes to the concept of "Complements," a series that by obsessively and consistently executing its inversions on all fronts ultimately undermines the aesthetic exceptionalism that I have criticized.

For indeed, it is the exceptionality of art that Robbins's "Complements" is after. I would propose one read "Complements," the very word *complement* (and both the complementary colors and Derridean supplement it evokes), in explicit opposition to art's exception and the exceptionalism of the art world—in opposition to what, with Stiegler, one might call "monarchical art." In response to such an exceptionalism of art, Robbins has chosen to make complementary art, which thrives in the complementary, supplementary, indeed inverted realm of the copy and seeks to propose an alternative aesthetics there. As paintings, one might think that these works are unexceptional, in the sense that they copy subject and composition of other works, even if they invert those works' colors and scale. But we are not dealing with paintings but with conceptual works. As such, these works *claim* their unexceptionality in order to challenge, precisely, an aesthetic judgment that would take root in an aesthetic exceptionalism that values originality. With Robbins's "Complements," we are in a realm in which unexceptionality is not a bad word but a positive indication that another kind of art, another kind of reason of and discourse about art, is possible. This is the power of its concept.

I want to emphasize that with "Complements," we are not leaving the realm of art, or proposing a relativist view of art within which everything and anything is art. If "Complements" opposes aesthetic exceptionalism, it does not do so as an art that one might call normal. Robbins's paintings are striking; as conceptual works they stand out. However, the distinctiveness of their strike, of their separation, cannot be captured by exceptionalism as such but only by its unworking—even if that is not quite an unworking all the way into the norm. As a term, and indeed a concept itself, "unexceptional" is meant to capture precisely this unworking,

which leads away from the exception if not quite into the norm. Within the unexceptional, there is still a reason one would find Robbins's work in the gallery, and not just any other work. A trace of the exceptional is preserved: aesthetic judgment, the value of the artwork, or art's vertical political reason does not go out the window entirely. This is still conceptual work by Alex Robbins, in the same way that Jacques Derrida still authors his texts. At the same time, however, art's exceptionalism is thoroughly unworked into something else.[28] We have come across this unworking in literature and theory, where the "author" has been declared "dead." Could the same be said about the artist? Why not? If today, as per Thierry de Duve's insightful analysis,[29] the aesthetic question is not so much whether a work is beautiful (Kant) but whether it is art (Duchamp), surely we should envision the overcoming of Duchamp's question as well into the death of art and the death of the artist? Wouldn't unexceptional art require this?

One should not be surprised if "Complements" does not catch the enthusiastic attention of the art world, whose reason operates otherwise. At best, one will find aesthetic appreciation for Robbins's work. But the danger it poses risks upsetting the art world's economic and political order, and therefore it is doubtful that the work will find praise within the art world as it currently exists. Instead, and the Monte Vista space is part of such a project, "Complements" is a deeply political series in the sense that it in-

28. In private correspondence, Robbins observed that there is an existential dimension to this issue as well, in the sense that the artist partly becomes who she or he is through exceptionalism—they need an exceptionalist trace to be someone in the world. One can easily see, of course, how an uncritical exceptionalism risks producing the egos for which the art world has become known. They too are product of an aesthetic exceptionalism that is theological. To develop the plea for unexceptional art, then, is also a *psychoanalytic* work that engages in *the unexceptionalization of how to be an artist in the world*.

29. Thierry de Duve, *Kant after Duchamp* (Cambridge, Mass.: MIT Press, 1998).

vites us to imagine another art world, based on another economic and political order. This would be an art world organized around the notion of the copy, not as something against which such a world needs to immunize itself but as the very element in which it operates. It would be an art world outside of the "one."

In such a world, Benjamin's celebrated essay (in which Stiegler inscribes his reading of aesthetics) would still be legible—but only partly. Its criticism of *mechanical* reproducibility would largely hold,[30] but not of reproducibility *as such*. With Robbins's work, we are between the mechanical reproducibility that is the condition of the capitalist, commodity-based economy—Robbins's embrace of the copy is obviously not that—and the aesthetic exceptionalism that (as per Dave Beech's analysis, for example[31]) would set art apart from such an economy. In reality, this separation of art from the commodity-based economy marks art's appropriation by the postcapitalist, financial economy, which is not commodity-based but relies on future-oriented speculation. Marina Vishmidt allows one to associate art with finance on this count, to think of art not as capitalist commodity but as speculative financial instrument.[32] Conceptual art historically emerges with this transition, and it may have a particularly intimate connection to financialization.[33] The task here, to evoke Benjamin

30. It should be pointed out that such a hold is enabled by human exceptionalism, i.e., the criticism of mechanical reproducibility does not only support the exceptionality of the original but also reinforces human exceptionalism.

31. See Dave Beech, *Art and Value: Art's Economic Exceptionalism in Classical, Neoclassical, and Marxist Economics* (Chicago: Haymarket Books, 2016).

32. See Marina Vishmidt, "Speculation as a Mode of Production in Art and Capital," https://qmro.qmul.ac.uk/xmlui/bitstream/handle/123456789 /8707/Vishmidt_M_PhD_Final.pdf?sequence=1.

33. I discuss this at some length in "Automatic Art, Automated Trading: Finance, Fiction, and Philosophy," in *The Edinburgh Companion to New Directions in Philosophy and Literature,* ed. Ridvan Askin, Frida Beckman, and David Rudrum (Edinburgh: Edinburgh University Press [forthcoming]).

once more, would be to think an aesthetic that is neither exceptionalist (and, in this way, tied to finance) nor about mechanical reproducibility (in the capitalist sense), one that would thereby institute another economy of art: that of the unexceptional copy.

Ultimately, I understand such an aesthetic as political, in the sense captured by this chapter's title: as an aesthetic against the monarchic. Although I have used the notion of monarchical art after Stiegler, as a historical understanding of art and specifically the notion of taste (hence aesthetics) as tied to the specific regime of monarchic government, it will have become clear that I also use it in what Stathis Gourgouris remarks is monarchy's literal, Greek-derived meaning: "μονη αρχη—singular authority, unique authority, but also, given the double meaning of archè [as both rule and origin], singular origin, unique origin."[34] By working against such a monological notion of art, Robbins also works against a monarchic politics of art or against what I call in more fashionable terms aesthetic exceptionalism.

34. Gourgouris, *Perils,* 63.

4. The Democratic Anarchy of Unexceptional Art

IT SEEMS THAT within the kind of art world that I have just evoked, an art world that would not be built on aesthetic exceptionalism, the Toporovski affair with which I started this book is nearly unthinkable. If I evoke such an art world, it is not because I want to offer a plea for indifference in the debate about the original and the copy or because I want to get rid of artists altogether. Rather, it is because it seems to me—and I hope I have made this clear along the way—that the Toporovski affair and the aesthetic exceptionalism that produces it also point to an economic and political exceptionalism in the arts that ought to be considered. How close is the aesthetic preference for the original, for example, and the aesthetic exceptionalism of such a preference—which extends into the exceptionalism of the artist—to Schmitt's theory of sovereignty, and its politics? How close is it to the economic exceptionalism of art that lies at the basis of the art market—of art's exorbitant prices and of the use of art, even, as a contemporary investment strategy?

Supposedly, the works from the Toporovski collection were removed from the Museum for Fine Arts in Ghent on art historical and pedagogical grounds, because questions had been raised about the authenticity of the works and because the general public may have been lied to about the works when they were exhibited in a public (and publicly funded) institution. But one has to wonder whether the public (and publicly funded) exhibition of forgeries is not *also* unthinkable because such an exhibition would undermine the economic and political order of the art world, if not Western thought more generally? If that were to be the case—and I have suggested it

is—what does the Toporovski affair tell us about the economic and political order of the art world (and perhaps of the West more generally), and about how that world is in the last instance structured by a certain kind of sovereignty and exceptionalism?

If the work of Carl Schmitt is a key reference in this conversation, I have also tried to nuance its role in it both by diversifying our understanding of Schmitt and by pointing out that "Schmitt" does not have the monopoly over the exception. It is possible to distinguish different kinds of exceptionalisms. And perhaps it is possible to stay within the limits of the Toporovski affair, to accept its condition (the attachment to the original), and mobilize such an exceptionalism for democratic purposes. But it seems to me that a democratic debate about aesthetic exceptionalism *did not take place* in the context of this affair. In other words, at no point was it asked whether, if the Toporovski collection consisted of forgeries that were actually good paintings—an aesthetic judgment that is obviously always up for debate, in excess of the issue of originality—it would have been conceivable to show those paintings at the museum.

Would it? Or would it not?

If not—and I expect that "No" would be the resonant answer—then what is the aesthetic, economic, and political philosophy of art that is upheld here? Can such a philosophy be called democratic? Or should it quite simply be recognized that the art world is aesthetically, economically, and politically an oligarchic and plutocratic environment—in other words, that it is profoundly antidemocratic? This is one way of saying that when it comes to curator Catherine de Zegher's eye,[1] it might have failed within a Western perspective, within the logic of aesthetic exceptionalism (the analysis of the works that were on display will have to pro-

1. I focus on the curator's eye here because de Zegher herself has brought it up. See gse, "De Zegher: 'Ik Had Geen Argwaan Over Collectie Toporovski,'" *De Standaard,* March 6, 2018, http://www.standaard.be/cnt /dmf20180306_03393143.

vide the evidence for this). But it also might not have failed from that other point of view that I have sought to develop: it might *not* have failed *outside of aesthetic exceptionalism*. In other words, the works shown at the museum were perhaps not what they were presented to be, and of course that ought to be corrected. But they might be interesting works, still. Is it a democratic element in art that makes the latter judgment impossible? Or something else?[2]

In her own account of the Toporovski affair, de Zegher concludes that she speaks for those who love beauty and truth.[3] But the latter—truth—is not *necessarily* tied to the former—beauty. Part of the issue is how the two come together in a scientific aesthetic institution like a museum, where one expects to encounter *both* the beautiful *and* the true. Even if the works in question turn out not to be true, they can still be beautiful, and therefore could still conceivably be worthy of exhibition in a scientific institution, as long as they are presented truthfully. Can we imagine this openness in the museum? If not, what does this tell us about the economics and politics of the museum as an institution?

Byung-Chul Han does not draw political conclusions from his work on Chinese deconstruction, but his thought about de-creation can be developed in such a direction. In the "final" volume of the Italian philosopher Giorgio Agamben's *Homo Sacer* series, which lays bare the fundamental biopolitical operation of sovereignty (its internal exclusion or exception of what Agamben after Walter Benjamin calls "bare life" within the limits of the *polis*, thus turning the *polis* into a camp[4]), Agamben describes a kind of power—or perhaps better, potential—that he dubs "des-

2. To be clear, I don't doubt that de Zegher decided to include the works for exceptionalist reasons, because she thought they were originals by the Russian avant-garde artists that the exhibition sought to celebrate.

3. See de Zegher, "Fake Art."

4. On this, see Giorgio Agamben, *Homo Sacer: Sovereign Power and Bare Life,* trans. Daniel Heller-Roazen (Stanford, Calif.: Stanford University Press, 1998).

tituent."[5] With this notion, Agamben wants to take on precisely the sovereign exceptionalism that I have associated with Schmitt. In the earlier volumes of his project, Agamben had traced such an exceptionalism back to the fact that the Greeks, in his analysis, had two words for life: *zoe,* or the simple fact of living shared by animals, humans, and gods; and *bios,* which refers to the qualified life of an individual or group—ethical or political life. The tragedy of Western power, as Agamben sees it, is played out in the dynamic between those two notions of life, with for example political protection being granted to living subjects as an addition to their *zoe,* thus including *zoe* within the sphere of *bios* only by virtue of its exclusion.

Agamben understands this internal exclusion to be an exception, and refers to the general state in which such a political logic is the case as "the state of exception." Whereas the latter, in Schmitt, tends to be associated with emergency situations, according to Agamben it has become the rule in contemporary Western societies. If the concentration camp is an extreme example of such a state, where its underlying logic is unsparingly laid bare, modern political societies have in fact continued to operate according to this rule, which is the rule of the exception. According to Agamben, the only way out of such a situation is to neutralize the vicious dynamic between *zoe* and *bios,* between the simple fact of living and its form, life and the form of life. To accomplish this, he develops in *The Use of Bodies* the enigmatic notion of form-of-life (with the hyphens), which had already come up at various other places in Agamben's work.

If the separation between *zoe* and *bios* can be traced back to a hylemorphic Aristotelian ontology (an ontology that is founded in the distinction between matter and form), as Agamben convincingly argues, form-of-life is meant to displace the basic opposition of

5. Giorgio Agamben, *The Use of Bodies,* trans. Adam Kotsko (Stanford, Calif.: Stanford University Press, 2016), 263.

that ontology by "contract[ing] into one another in a peremptory gesture" the notions of *zoe* and *bios,* thus "taking leave of classical politics."[6] In Agamben's view, this "points toward an unheard-of politicization of life as such":

> The wager here is that there can be a *bios,* a mode of life, that is defined solely by means of its special and inseparable union with *zoe* and has no other content than the latter (and reciprocally, that there is a *zoe* that is nothing other than its form, its *bios*). Precisely and solely to the *bios* and *zoe* thus transfigured do there belong the attributes of political life: happiness and autarchy.[7]

It is this new form of contract theory (as I have characterized it elsewhere) that Agamben finds in form-of-life (with the hyphens marking the contraction, visualizing it on the page).[8]

Exceptionalism, for Agamben, can thus be traced back to the dynamic between *zoe* and *bios.* Translated into aesthetic exceptionalism, I want to propose an analogy with the dynamic between the original and the copy, with the museum—in parallel to modern Western states—emerging as what Agamben calls a camp, where works (*zoe*) are only included by virtue of their being labeled original and authentic (*bios*), an inclusion that truly operates as an internal exclusion or exception given that when works—even if they are good works—are exposed to be forgeries, they will be removed from the museum.[9] Here, it becomes clear that the distinction

6. Agamben, 219.

7. Agamben, 219.

8. For Agamben, such a contraction is a Platonic gesture, but to understand this one must delve into his idiosyncratic reading of Plato, which I will leave for another time.

9. Agamben comes closest to this analogy in his book *The Man without Content,* trans. Georgia Albert (Stanford, Calif.: Stanford University Press, 1999). Following this analogy, one must risk rewriting Schmitt's famous dictum about all significant modern concepts of the state as follows: all significant modern aesthetic concepts (concepts of the museum and the gallery, if you will) are secularized theological concepts. Doing so would then in turn lead one to consider the residue of sovereignty, and monarchical sovereignty in particular, in modern aesthetics.

between a good and bad work of art ultimately operates in a way different from that between the original and the copy. Whereas the former comes about by subjective determination, whether individual or collective, the latter can be objectively determined. As such the logic of exceptionalism is much more effective in the latter than in the former, even if traces of the exceptional are of course retained in any aesthetic judgment.[10]

A further analogy that can be made, looking back at my discussion of Alex Robbins's "Complements" but also looking ahead at the next part of this book (in which Agamben's work will be central), is to the dynamic between nudity and clothing, with *zoe* being nudity and clothing, *bios*—something that I have laid out already in a different context.[11]

I want to underline with respect to the distinction between aesthetic judgment (good art versus bad art) and the question of the original versus the copy, that there are other aspects of the work

10. I have already considered the complicities between Schmitt's theory of the exception and Kantian aesthetics (specifically, Kant's theory of the sublime and of the genius) in chapter 1. It is within Kant, however, that one finds the split between a Schmittian exceptionalism (of the sublime and of genius) and a democratic exceptionalism. The latter I would associate, following a certain tradition of political thought, with the aesthetic judgment of the beautiful. My proposal would be that aesthetic theory has tended toward the sublime of the Schmittian exception rather than the democratic exceptionalism of the beautiful. I will want to return to the beautiful and the trace of exceptionalism it maintains in the next chapter. The split in Kant between the sublime and the beautiful can be said to mirror, more generally, the split between argument and obedience in, for example, Kant's classic text "What Is Enlightenment?" (see Boever, *Plastic Sovereignties,* chapter 5), or more generally the split between his moral theory and his theory of aesthetic judgment that Hannah Arendt in her reading of Kant has drawn out. Arendt's difference on this count from other readers of Kant is enabled by precisely this split. On this second, Arendtian point, see Martín Plot, *The Aesthetico-Political: The Question of Democracy in Merleau-Ponty, Arendt, and Rancière* (New York: Bloomsbury, 2014), 71–74. On another occasion, I would like to consider Schmitt's *Political Romanticism* (trans. Guy Oakes [Cambridge, Mass.: MIT Press, 1986]) in this context.

11. Boever, *Plastic Sovereignties,* 25.

of art that operate like the aesthetic judgment in relation to aesthetic exceptionalism—in other words, other aspects of the work of art that unwork aesthetic exceptionalism. For example, in his auto-fictional novel *10:04,* Ben Lerner takes inspiration from Elka Krajewska's "Salvage Art Institute" to create a character called Alena who with an artist friend called Peter has started an institute that collects and intends to display for public viewing "totaled" art, i.e., art that has somehow been damaged and, as a result, has been declared to have "zero value."[12] In some cases, the damage is visible, even to the untrained eye. But in others—and those will turn out to be the cases that most interest the novel's narrator, as Nicholas Brown has pointed out[13]—it is not. That begs the question of what exactly caused the artwork to be labeled as "damaged." Whatever the case might be, "totaled" artworks are works that "were formally demoted from art to mere objecthood and banned from circulation, removed from the market."[14]

It is probably no coincidence that when *10:04*'s narrator visits Alena's institute, he is handed "the pieces of a shattered Jeff Koons balloon dog sculpture."[15] "It was wonderful," he notes, "to see an icon of art world commercialism and valorized stupidity

12. Ben Lerner, *10:04* (New York: Faber & Faber, 2014), 129. The discussion of *10:04* that follows is taken from my book *Finance Fictions: Realism and Psychosis in a Time of Economic Crisis* (New York: Fordham University Press, 2018). I would like to thank my editor Tom Lay as well as Fordham University Press for permission to republish this discussion here in an adjusted form.

13. Nicholas Brown, "Art after Art after Art," *Nonsite.org, no.* 18 (2016): http://nonsite.org/feature/art-after-art-after-art.

14. Lerner, *10:04,* 130.

15. Lerner, 131. Stories about broken Jeff Koons sculptures have popped up occasionally, and one in fact appeared while I was preparing this book. See Golden Darroch, "From Gazing Ball to Crazy Paving: Koons Sculpture Goes to Pieces in Amsterdam Church," *Dutchnews.nl* April 9, 2018: https://www.dutchnews.nl/news/2018/04/from-gazing-ball-to-crazy-paving-koons-sculpture-goes-to-pieces-in-amsterdam-church/.

shattered."[16] When Alena picks up one of the smaller pieces from the narrator's hand "and hurled it onto the hardwood, where it shattered," she hissed "It's worth nothing."[17] The declaration gains part of its power from the fact that Koons is one of the most expensive living artists. The visit to the Institute for Totaled Art has a profound effect on *10:04*'s narrator. Contemplating a Cartier-Bresson that is part of Alena's collection, he notes:

> It had transitioned from being a repository of immense financial value to being declared of zero value without undergoing what was to me any perceptible material transformation—it was the same, only totally different. This was a reversal of the kind of recontextualization associated with Marcel Duchamp, still—unfortunately, in my opinion—the tutelary spirit of the art world; this was the opposite of the "readymade" whereby an object of utility—a urinal, a shovel—was transformed into an object of art and an art commodity by the artist's fiat, by his signature. It was the reversal of that process ...[18]

Koons is the primary target of that process, but the novel also mentions Damien Hirst.[19]

The reference to Duchamp is worth pursuing given my discussion of Duchamp in the previous chapter. For we gain here a deeper understanding of what Robbins is doing with Duchamp in "Complements": if Duchamp's readymades, according to Lerner's narrator, were about putting an object of utility in the museum and thereby transforming it into an art object, the Institute for Totaled Art is about turning an art object into an object of utility, thereby opening up its monarchic form onto democratic use. I am not sure I agree with Lerner's narrator's assessment of Duchamp. It seems doubtful, based on what I said about Duchamp in the previous chapter, that his project was indeed to turn utility objects into art. The goal was never to make an original and to get an original into the museum, to get it recognized

16. Lerner, 131.
17. Lerner, 132.
18. Lerner, 133.
19. Lerner, 133.

as art. Instead, especially in view of Duchamp's later assessment of the readymades as always already a replica, it seems that Duchamp's basic gesture was always already what Lerner's narrator considers to be a reversal. Duchamp was always already reversing; as a home for his work, there was never anything other than the Institute for Totaled (which I would read as "deconstructed" rather than "destructed," as per my discussion of Derrida previously) Art.

Clearly, what fascinates *10:04*'s narrator is not so much the valuation of the artwork but its devaluation, or better (as will become clear in a moment) revaluation: how can the artwork be removed from the art market? It's worth noting that the author captures those questions in capitalist terms. He describes the artwork's removal from the art market as an artwork no longer being "a commodity fetish; it was art before or after capital"[20]—that is part of his fascination with it. He also explicitly gives this before or after a messianic dimension: in Alena's project, art is "saved from something" "in the messianic sense," "saved for something":

> An art commodity that had been exorcised (and survived the exorcism) of the fetishism of the market was to me a utopian readymade—
> an object for or from the future where there was some other regime of value than the tyranny of price.[21]

The author is overwhelmed by the genius of this revaluation, of this other regime of value. Ultimately, Alena's art and what it accomplishes are associated with the alternative messianism that the author finds in Benjamin: everything will be as it is now, just a little different.[22] As Lerner himself makes clear in his acknowledgments, this is a line from Benjamin that Lerner actually comes in across in the work of . . . Giorgio Agamben.

Everything operates here, in other words, within the sphere of Agamben's thought and the movement toward form-of-life that

20. Lerner, 134.
21. Lerner, 134.
22. Lerner, 135.

would break down the dynamic between *zoe* and *bios*. Lerner enables us to see one way in which such a movement can already be found within the existing art world, through his engagement with the Institute for Totaled Art. It may just as well have been called the Institute for Unexceptional Art: it's art still, and it clearly retains a trace of the exceptional. But within the aesthetic exceptionalism that structures the art market, it is profoundly unexceptional. And it is of course as such that Lerner's narrator finds it interesting: as unexceptional art that stands outside of the art world's aesthetic and economic logic.

With Agamben—but this partly lies concealed in Lerner as well, whose novel is generally considered to be about the contemporary neoliberal moment[23]—we are propelled toward a political reading of such an "outside." The unexceptional would need to be conceived, in Agamben's terms, as a kind of "destituent potential" that would unwork the Aristotelian ontology underlying Western politics—an ontology that is very much present in the valuation of the original over the copy that structures the Western art world, its aesthetics, economics, and politics. For Agamben, it is "destituent potential" that unworks political exceptionalism of the kind that can be found in Schmitt. This involves, he suggests, "think[ing] entirely different strategies": it is not about "revolutions, revolts, and new constitutions," the dynamic between constituting and constituted power.[24] When it comes to bringing "destituent potential" in conversation with an already existing political name, the closest Agamben comes to that is in his turn toward "anarchy," toward an "anarchist tradition" that has "sought to define [destituent power]

23. See, for example, Hari Kunzru, "Impossible Mirrors," review of Ben Lerner, *10:04*, *New York Times Sunday Book Review*, September 7, 2014; Pieter Vermeulen, "How Should a Person Be (Transpersonal)? Ben Lerner, Roberto Esposito, and the Biopolitics of the Future," *Political Theory* 1, no. 23 (2016): 1–23.

24. Agamben, *Use*, 266.

without truly succeeding in it."[25] In a way, Agamben can be considered to be taking up that anarchist project, even if in the closing pages of *The Use of Bodies* that particular challenge ultimately remains undeveloped. Indeed, the book reads not so much as a concluding volume to a series but as a text in which the project of the series is "abandoned," as Agamben puts it in a prefatory note.[26]

In order to pursue this suggestion of an "anarchist" politics a little further, let me loop back to the political references that were used at the beginning of this book. Schmitt, and by association a thinker like Badiou, is inconceivable within what Han calls "Chinese thought" (no matter Badiou's love for Mao). However, and this is where I would counter the reading that Steven Corcoran provides of his thought (see chapter 1), Rancière could perhaps still fit, given that he claims to reconceptualize the exception precisely *not* as Badiou's grand rupture. Possibly recognizing the potential problems of Badiou's thinking on this count, Rancière has in an interview insisted that if there is an exception in his theory, it is different from Badiou's theory of the event: for him the exception is always ordinary, he insists, coming "not out of a decision or out of a radical rupture" but out of a "multiplicity of small displacements."[27] This resonates with the work of Bonnie Honig and the exceptionalism of the ordinary that she defends. Rancière's theory of transformation marks, in that sense, a "Chinese" or "Buddhist" unworking of a Western theologico-political thought of rupture.

It is interesting how the notion of "anarchy" appears in this context.[28] When in his "Ten Theses on Politics" Rancière seeks to characterize "democracy," he mentions Cleisthenes's famous democratic experiment, wherein "democracy is characterized by the

25. Agamben, 275.

26. Agamben, xiii.

27. Abraham Geil, "Writing, Repetition, Displacement: An Interview with Jacques Rancière," *Novel* 47, no. 2 (2014): 301–10.

28. This paragraph as well as the following are taken from my "Art and Exceptionalism."

drawing of lots, or the complete absence of any entitlement to govern. It is the state of exception in which no oppositions can function, in which there is no principle for the dividing up of roles. . . . Democracy is the specific situation in which it is the absence of entitlement that entitles one to exercise the *archè*."[29] Rancière takes this exceptionalist understanding of democracy from Plato's *Laws,* in which Plato "undertakes a systematic inventory of the qualifications (axiomata) required for governing and the correlative qualifications for being ruled."[30] Plato retains seven, four of which (Rancière notes) are based on "natural difference, that is, the difference of birth."[31] "The fifth qualification . . . is the power of those with a superior nature, of the strong over the weak."[32] The sixth, which Plato considers most worthy, is that of "the power of those who know over those who do not"[33]—hence, his preference for philosopher-kings. But, Rancière notes, Plato adds a seventh qualification that produces what he considers a "break in the logic of the *arkhè*."[34] Plato calls this seventh qualification "the choice of God" or "the drawing of lots."[35]

This is how Rancière arrives at his understanding of democracy as "the state of exception." If such a democratic state is "anarchic," this is not because of its total absence of *archè,* but because it produces a break in the *logic* of *archè,* in that *it turns the absence of the entitlement to rule into the entitlement to rule*—into a "commencement without commencement, a form of rule (*commandement*) that does not command."[36] In other words: there is rule, but not as before. This is a state of exception, as Rancière sees it, but one

29. Jacques Rancière, *Dissensus: On Politics and Aesthetics,* trans. Steven Corcoran (London: Continuum, 2010), 31.

30. Rancière, 30–31.

31. Rancière, 31.

32. Rancière, 31.

33. Rancière, 31.

34. Rancière, 31.

35. Rancière, 31.

36. Rancière, 31.

"that more generally makes politics in its specificity possible."[37] This is why democracy for Rancière is not so much a political regime but the name of politics as such. Democracy, like politics, is what produces a break within the logic of ruling as such. This has something to do with the particular anarchy that it brings. Anarchy, then, does not so much refer to the absence of all rule but to the democratic break in the logic of a rule that is exercised by one "determinate superiority" over "an equally determinate inferiority."[38] It refers to the rule of equality.[39] In other words: Rancière claims democracy as anarchic and in that sense as politics due to its rule of equality, its rule that is based on the absence of any entitlement to rule. While such a position obviously marks a kind of shock, and an exception in this sense—it does, after all, accomplish a break in the logic of the *arkhè*—it is worth noting that such a shock or exception does not do away with all rule. Indeed, it is folded back within the rule—a wholly transformed rule.

It is no wonder that Agamben has revealed himself to be rath-

37. Rancière, 31.

38. Rancière, 30.

39. This understanding of anarchy is clear throughout Rancière's work, from his book *The Ignorant Schoolmaster: Five Lessons in Intellectual Emancipation* (trans. Kirstin Ross [Stanford, Calif.: Stanford University Press, 1990]) onwards. In the first chapter of that book, for example, Rancière develops a criticism of the *"archè"* of "explication." This is clear from the fact that he distinguishes the following two dimensions of explication: "On the one hand, [the explicator] decrees the absolute beginning" (6)—*"archè"* in the sense of "beginning." "On the other," he continues, the explicator "appoints himself to the task of lifting" "the veil of ignorance [that s/he has cast] over everything that is to be learned]" (6–7). This is *"archè"* in the sense of "rule"—the master rules through appointing her-/himself this task. This is what Rancière later calls the "hierarchical" setup of explication. Of course, by making the case for an ignorant schoolmaster, Rancière seeks to intervene in this. But how exactly? He proposes a kind of an-archy, but not the loose sense of anarchy that gets rid of the master altogether—it's an an-archy that is "not . . . without a master" (12), as he points out. This is the anarchy of an emancipatory teaching situation, of an equality and democracy of intelligences, freed from the hierarchy of *archè*— or rather, operative after a radical transformation in the logic of *archè*.

er critical of Rancière given that, first of all, Rancière is still an exceptionalist thinker and, second, he is ultimately attached to some form of constituted power.[40] While everything political in Rancière challenges constituted power, which Rancière associates with the police, politics also always moves in the direction of a newly constituted—more equal—order. With the notion of destituent potential, Agamben is precisely trying to steer clear from this.

In his thought about anarchist democracy, which is part of his thinking against the monarchical that I discussed at the end of the previous chapter, Stathis Gourgouris may have drawn the right conclusion on the basis of Rancière's central idea. If in an anarchist democracy as Rancière describes it everyone is equally entitled to govern, Gourgouris argues, then anarchist democracy is precisely unexceptional—for everyone, *without exception*. Following Emily Apter,[41] he embraces the notion of an unexceptional politics:

> I favor this notion because for me democracy is precisely the regime that does not make exceptions, if we are to take seriously Aristotle's dictum of a politics where the ruler learns by being ruled, making thus the ruled simultaneously the rulers, in a determinant affirmation of an *archè* that has no precedent and no uniqueness but is shared by all. No exceptions. The obvious politics of partiality and discrimination or exclusion in so-called modern democracies testifies to their fraudulent use of the name. Contemporary democratic states are no more than liberal oligarchies.[42]

As Gourgouris sees it, unexceptional politics goes against the theologization of politics (which he associates with Schmitt):

40. Giorgio Agamben, *The Time That Remains: A Commentary on the "Letter to the Romans,"* trans. Patricia Dailey (Stanford, Calif.: Stanford University Press, 2005), 57–58.

41. Apter, *Unexceptional Politics*.

42. Stathis Gourgouris, "The Question Is: Society Must Be Defended against Whom? Or What?" *New Philosopher*, May 25, 2013, http://www.newphilosopher.com/articles/the-question-is-society-defended-against-whom-or-what-in-the-name-of-what/.

I am interested instead in a politics where nothing is miraculous, where indeed nothing is sacred, where there is no *Homo Sacer* [this is a reference, obviously, to Agamben's project]. This would be an unexceptional politics, an untheologized politics. It would have to be necessarily an anarchic politics, as democratic politics is at the core, insofar as *archè* is unexceptionally shared by all and therefore lapses as a singular principle. Anarchy as a mode of rule—democratic rule par excellence—raises a major challenge to the inherited tradition of sovereignty in modernity.[43]

When it comes to politics, many artists would be ready to embrace this. They would be ready to embrace the unexceptionalism of such an anarchist democracy. However, when it comes to art, the situation appears to be very different. Unlike "unexceptional politics," "unexceptional art" receives a much less warm embrace, if it is welcomed at all. People, in particular artists, tend to find "unexceptional art" offensive. To think of art as unexceptional—now that goes against the very core of what we believe art is!

But that difference in reception leads to the strange situation that in art we praise what in politics we find dubious. To be fair, art and politics *are* different—so perhaps it is just fine to find dubious in politics what we praise in art. Perhaps we can pursue in art what we think can't be pursued in politics, and perhaps it is better to pursue those things in art rather than in politics. Perhaps art is where we can exorcise the demons by whom we'd prefer not be haunted in politics. But to the extent that both art and politics operate in the imaginary, and in that sense mutually support each other (with artistic imaginaries passing into politics, and political imaginaries into art), art is not separate from politics—and vice versa. In part, that means one can expect some consistency between the two realms. When it comes to exceptionalism, it seems there is none: exceptionalism is treated as suspicious in politics, but loved in art. I have tried to nuance both claims, the former by pointing out multiple exceptionalisms in politics (some more

43. Gourgouris, "The Question Is."

dubious than others) and the latter by questioning the dubious exceptionalisms that structure the art world: aesthetically, economically, politically.

"Fine," you will say. "I am convinced. Now show me some unexceptional art."

"Durant's *Scaffold* doesn't make the cut, because you've presented it here as a work of monarchic art around which a democratic exceptionalism came into being. That's exceptionalisms all around."

"The only example of unexceptional art you have given is Robbins's series 'Complements,' which is nice but not enough."

"We want more."

To this one must respond that unexceptional art is not an indexical notion. By this I mean that one cannot point at some art and say it is unexceptional, and then point at some other art and say it is not. As opposed to an ontology of unexceptional art, as opposed to a metaphysical definition that would capture its essence, one should think of the unexceptional as a concept naming a procedure or operation that unexceptionalizes the Schmittian exceptionalism constituting the art world. The unexceptional is in that sense a negative concept that cannot be positively defined.

However, there are certain people and realms in which the force of the unexceptional is potentially strong. Whereas aesthetic exceptionalism exists first and foremost on the side of the spectator, who takes in and fetishizes the work of art, the procedure or operation of the unexceptional takes place first and foremost with artists themselves, with those who make the work and know how the work was made; it also takes place with the art handlers, those who pack up and ship the work and install it in galleries, museums, or private homes. It takes place with those who sell artwork. It takes place with those who own artwork. It takes place with those who work in art environments (not only galleries or museums but also art schools, for example) and encounter art while it is being made, before it goes on show, and after the show is taken down. It appears, however, that the aesthetic exceptionalism asso-

ciated first and foremost with the spectator has pervaded all of the above, in a kind of spectator-ization (to follow a famous analysis) of the artworld.[44] Such a becoming-hegemonic of the spectator's experience of art as exceptional has undone the unexceptionalism of art on all fronts.

To be close to art, however, is to be in proximity to the unexceptional. This does not require *connaisseur*-ship, at least not of the kind associated with aesthetic exceptionalism. It requires a kind of knowing, to be sure, a kind of *connaître* or *savoir,* but a knowing whose verticality has been thoroughly unworked, even if traces of it remain. It is to be hoped that, in a reverse move, the unexceptionalism of such a knowledge will one day take over the experience of the spectator, unworking their exceptionalism into the unexceptional, so that they will be able to see art for what it is: just art. There is something "secular" about this, in Edward Said's sense of the term, in that it asks us to acknowledge first and foremost art's worldliness.[45] In the end, the artist at work is just that: at work in the world, doing what they do every day. Their art is just that: the unexceptional, worldly—secular—product of their labor.

The rest is aesthetic exceptionalism.

44. In *The Man without Content,* Agamben points out that this was precisely the issue that Nietzsche had with Kant. Kant's theory of aesthetics, Nietzsche argued, operated from the point of view of the spectator. It is of course in Kant's time that many of the issues I have discussed here are born. Nietzsche responds to all of this—the institution of the exceptional realm of art in the eyes of the spectator—with an exceptionalism of the artist. But this did not solve the core of the problem he had identified. Nietzsche, too, is within the realm of aesthetic exceptionalism—but from the artist's side.

45. Edward Said, *The World, the Text, and The Critic* (Cambridge, Mass.: Harvard University Press, 1983).

5. Complement: Naked Painting (On the Work of Becky Kolsrud)

I WANT TO RETURN NOW to the discussion of the nude that I opened up in my reading of Alex Robbins's series of paintings "Complements." I suggested that Robbins's decision to copy mostly paintings of nudes (the Sargent painting is the only exception) was an engagement with the distinction between the original and the copy that supports the aesthetic exceptionalism structuring the Western art world. In the same way that Robbins inverts the relation between original and copy, his work inverts the relation between nudity and clothing: Robbins's use of inverse colors makes naked bodies appear as clothed, and clothed bodies—I discussed Mrs. Carl Meyer in Sargent's *Mrs. Carl Meyer and Her Children* in particular—as naked.

While these inversions are obtained in Robbins's work through painting, I hesitated to characterize his works as such, opting instead for the term "conceptual" as a more exact determination of their status. By presenting us with something like conceptual painting, Robbins arguably deconstructs the distinctions between retinal and non-retinal, painting and readymade, that are the target of Marcel Duchamp's early twentieth-century work. Projecting the readymade—always already a replica, never original let alone "an" original—back into (mostly) modernist paintings, Robbins presents the viewer with an unexceptional art that subverts, I suggested, not only aesthetic exceptionalism but also the economic and political exceptionalism that it enables.

In this final section, I propose a reading of how the art of another Los Angeles–based painter, Becky Kolsrud, unworks aesthetic exceptionalism through its intervention in the painting of nudi-

ty. By unworking the dynamic between nudity and clothing, and foregrounding the materiality of painting itself, Kolsrud unexceptionalizes the status of the naked body in art, and by extension the structuring logic of the contemporary art world (which is built on exceptionalism). If in my reading of Robbins, the distinction between the original and the copy was foreground, and that between nudity and clothing background, here the distinction between nudity and clothing becomes foreground against the background of the criticism of the distinction between the original and the copy that I have already provided. If in my reading of Robbins I tended to come down on the conceptual in my discussion of paintings, here I allow this book's conceptual framework to move resolutely in the direction of painting, so as to let just painting (in the sense of mere or unexceptional painting) materialize itself.

It should not come as a surprise that the nude ends up playing an important role in any investigation of aesthetic exceptionalism. As François Jullien, the sinologist whose work I relied on in the third chapter, has argued in his book *The Impossible Nude*, "the nude is a paradigm of what the 'West' consists of in cultural terms, and brings to light the stances that originally underpinned our philosophy."[1] He mentions, immediately following, "the question of essence, of the 'thing itself,'"[2] in other words: of the nude's relation to Western ontology and metaphysics. If the nude is interesting to Jullien, it is because it does not allow us to imagine a metaphysical beyond. "Part of the real stops there," he writes. "After the nude there is nothing more. . . . It is the end, *the very point of contact.*"[3] As such it "always has the impact of an immutable revelation: the 'everything is there,' 'this is it,' with no horizon or receding perspective, no beyond. All the rest is merely allusive. . . . There is

1. François Jullien, *The Impossible Nude: Chinese Art and Western Aesthetics,* trans. Maev de la Guardia (Chicago: The University of Chicago Press, 2007), vii.

2. Jullien, vii.

3. Jullien, 2.

nothing to be decoded in it, the nude is no longer a sign, the unsurpassable is simply there, before our eyes."[4] The nude "surg[es] out," it is "stunning"; Jullien characterizes it as an "event, offered like a miracle for contemplation."[5] He contrasts it on these counts to nakedness, which always "implies a diminished state."[6] The nude, on the other hand, "tends toward the Ideal and serves as the 'image' (eikon) for the Idea."[7] In that sense, it "turns toward the 'divine'"[8]—not at all towards the oblique and the discreet that, under the header of "blandness," Jullien has praised as key elements of Chinese thought.[9] Hence the philosophical impossibility of the nude in Chinese painting for which Jullien's book argues. The other side of that conclusion, however, is that the nude is the aesthetic realization of Western exceptionalism, and it is from that point of view that I pay special attention to it here.

Let me begin with what might appear to be a counterintuitive statement: Becky Kolsrud does not paint nudes. In *Bather with Red Shoes* (2018), for example, the red parts—the shoes, the nailpolish, and the lipstick—stand out too clearly for anyone to comfortably call the painting a nude.

If the bather from the painting's title is possibly nude underneath the water, it should be noted that the painting pointedly does not tell us whether this is so. Instead, dark blue water, which is supposed to be transparent, veils the bather's body and turns the painting into something else—*not* a nude. In fact, the water veils the body to such an extent that one begins to doubt whether there is an actual body present underneath the water. The head,

4. Jullien, 3.
5. Jullien, 36.
6. Jullien, 4.
7. Jullien, 7.
8. Jullien,
9. François Jullien, *In Praise of Blandness: Proceeding from Chinese Thought and Aesthetics,* trans. Paula M. Varsano (New York: Zone Books, 2008).

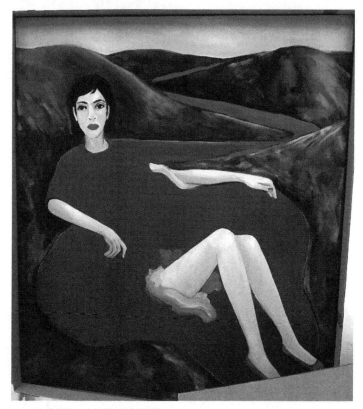

Becky Kolsrud, *Bather with Red Shoes.*

arms, and legs feel dismembered, not quite connected into a larg-
er (underwater) whole. For further proof, just consider *Floating
Head* (2018), which intensifies this feeling: there might not be a
body, let alone a naked body, under the water. This might just be
a floating head.

This point about nudity is made even more starkly in *Resting
Bather* (2018), where light-blue water confronts the viewer like a
block: opaque, material, it appears like something solid onto which

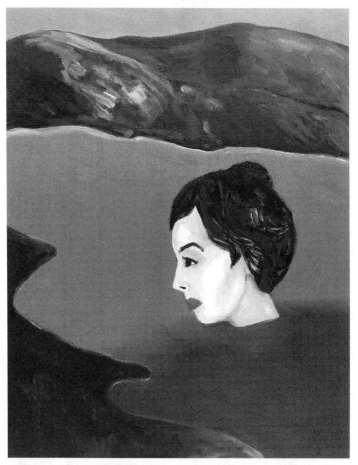

Becky Kolsrud, *Floating Head.*

the bather—possibly nude, but again there is no way to tell—rests her arms and her head. This water is so *hard,* the painting seems to say, that you can *lean* on it. Once again, there is no nudity here. Or if there is, it is not the nudity of the bather. I would propose, instead, that *Resting Bather* shows us *naked painting.* What else

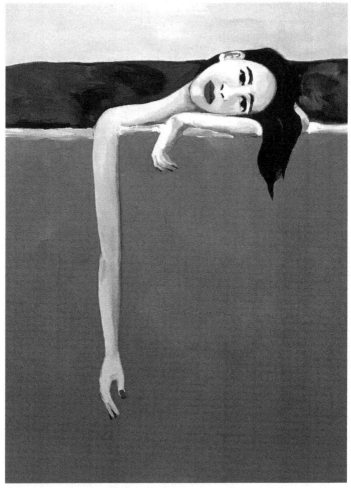

Becky Kolsrud, *Resting Bather.*

to call the vertical, rectangular slate of blue that covers most of the painting? It is *naked, unexceptional painting,* rather than a *painting of a nude.*

The Three Graces (2018) bathes in the same light-blue of *Resting Bather*, but this time the blue actually marks a piece of clothing, a kind of hooded cloak for triplets (if such a thing exists). Of course by now, one doesn't so much see clothing but water, as if *The Three Graces* are bathing even if they are clothed. Covered when one is supposed to be naked, as in *Bather with Red Shoes* and *Resting Bather*, and naked when one is supposed to be covered, as in *The Three Graces*, Kolsrud's painting seems to play with nudity and the painting of nudity rather than to deliver it, offering us a kind of naked painting instead.

This is so even in a work that comes closest to being identifiably a nude. Titled *Nude in Snow* (2018), it shows a naked female body that appears to be bathing in what one imagines to be ice-cold water. The body is naked, and visibly naked in the water, but even here it is partly hidden from view by snow, "in snow," as the painting's title puts it. Due to how the snow has been represented—as crude dots of white applied across the painting's canvas—the viewer once again gets the sense that they are not so much seeing a nude, or even a nude in snow, but a nude *in paint* or a kind of *naked painting*. If this painting comes closest to showing an actual nude (even if it is a nude that is partially covered), it is also a painting that through its crudely painted dots of snow shows painting itself, and shows it quite nakedly. It is probably worth noticing that the snow, or the paint, is in the foreground here. The nude in the background may in fact be a distraction. The painting shows, rather, painting itself. Naked. Kolsrud does not paint nudes, then, but she *does* paint naked painting.

In 2017, just one year prior to the already discussed works, Kolsrud titles one painting *Allegory of a Nude II*. Not quite a nude, but an allegory of a nude—a work in which, if we follow Walter Benjamin's understanding of allegory, the nude would lie in ruins and the passage from nudity to its allegory would not quite be accomplished. Light-blue water appears to swirl up like Marilyn Monroe's dress in that famous photograph, billowing around a female figure's body like a piece of cloth in the wind (but note the difference between

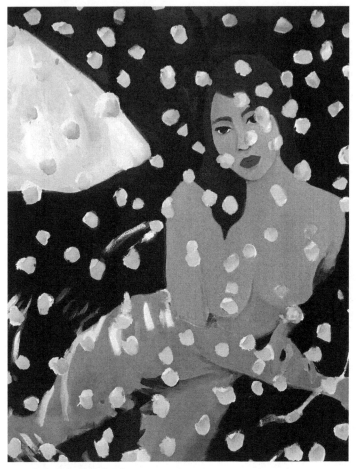

Becky Kolsrud, *Nude in Snow.*

this female figure and Monroe—I will come back to the figure's ex-
pressionless face later on). Supposedly transparent—and a trace of
its transparency indeed remains; there is the patch of water cover-
ing the figure's upper right thigh—water already appears opaque

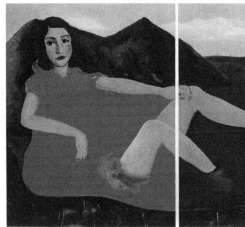

Becky Kolsrud, *Clear Boot Diptych.*

and material here as it does in the later paintings, even if it does not yet have the block-like feeling of solidity (as in *Resting Bather"*). *Bather in Red* (2017) anticipates *Bather with Red Shoes,* but here too Kolsrud hasn't gone quite as far yet in her materialization of painting: some of the bather's body still shines through, more so in any case than in the work from 2018.

Water covers the body in *Clear Boot Diptych* as well, its opacity and materiality emphasized not only by the contrast between the light-blue water in the canvas on the left and the dark-blue water in the canvas on the right but also by the fact that the one item of clothing in the painting, the one thing that is supposed to cover up, is transparent or "clear." One can see through it. The foot thus becomes strangely naked, even if it is covered—perhaps even more so than those naked parts of the body that are visible in the painting (the legs, the arms, the head; again, they feel dismembered, as if the cut in the middle of the painting were the sign of one of those magic tricks in which a woman's body is cut in half and then miraculously restored to a whole afterward). When the boot returns in *Underwater Boot* (2017), it is in a painting in which bodies and faces are almost

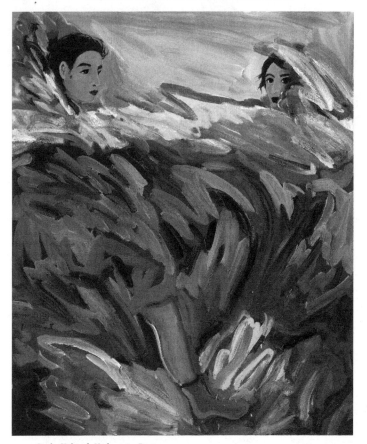

Becky Kolsrud, *Underwater Boot.*

entirely hidden from view by stormy waters. The painting gives the *nude,* the traditional nude, the *boot,* so to speak: it puts the naked body under water—and the underwater boot does look like it's kicking, in the painting—and all it shows is the water, crudely painted, naked, not as water but as paint. *Underwater Boot* is, in its simplicity, *over*-painted. *It gives nudity the boot in favor of naked painting.*

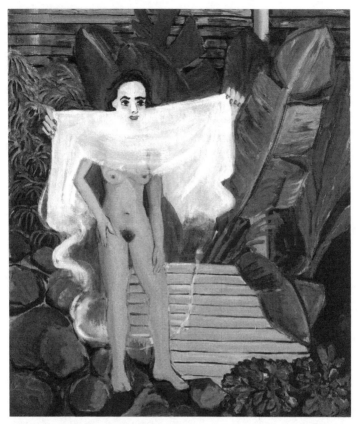

Becky Kolsrud, *Allegory of a Nude I.*

Allegory of a Nude I and *Covered Nude* make this point in a more complex way, a complexity that—in my view—the more recent work overcomes in favor of a simpler, more unapologetically straightforward painterly statement. Here, female figures are pictured to hold up, as if to show the viewer, what appear to be pieces of cloth—a shawl, perhaps, in *Allegory*, or a bathing towel (in *Covered*). But those pieces of cloth are held up like a canvas that in

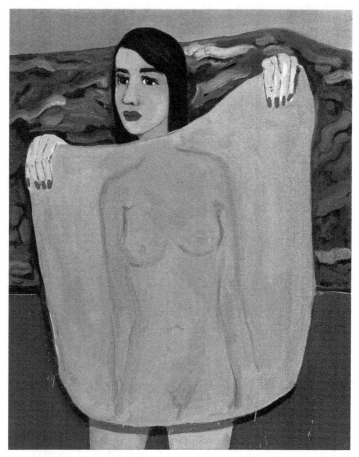

Becky Kolsrud, *Covered Nude.*

the former work appears to be transparent but is obviously paint-
ed, and in the latter work appears to reveal the shapes of the naked
body underneath—but the shapes obviously do not match the hid-
den body. In *Allegory*—and here again we can follow Benjamin—
the passage from one level of reality to the other is not quite estab-

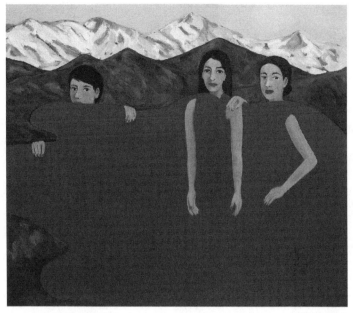

Becky Kolsrud, *Three Women*.

lished: it's either the nude body that is painted onto the shawl or the shawl that has been painted onto the naked body. The painting does not quite let us decide. In *Covered*, it seems quite clear that the towel was painted: light-blue paint can be seen dripping off the towel in the lower, dark-blue part of the painting.

Three Women is the work from 2017 that is the farthest ahead in this series, very close already to works like *Bather with Red Shoes* or *Resting Bather* from just a year later (and anticipating as well, obviously, the figure of three that will appear in *Three Graces*). *Lady Underwater* is, within this narrative, a transitional work—it paints water as transparent, as not covering the naked body. It stands in between the more traditional nudes from 2017—*Nude Ascending, Bathers with Backdrop*—which need to be read in opposition to the nonnudes from 2018. I read *Double Mountain/*

Backdrop as a transitional piece as well: removing the traditional nude from the center of attention, the work foregrounds the crudely painted double mountain—and *doubled,* for those viewers for whom a single mountain wouldn't have quite gotten the message across—an emphatic brushstroke that is further emphasized by the elaborately painted, wallpaper "backdrop" from the painting's title. If Kolsrud moves away from the nude here to the foregrounding of *painting itself,* but at the cost of painting the nude, the contribution of the more recent work is that it manages to combine the two and keep the nude in the center while at the same time offering us naked painting. It is a remarkably fresh, unapologetic embrace of painting and at the same time an intervention (by a woman painter, one might note) in art history's long and in many ways problematic history of painting female nudes (mostly done by men, one might further note).

In an article titled "Nudity,"[10] which starts with a discussion of a performance by Vanessa Beecroft, Giorgio Agamben criticizes how in Western thought "nudity" has always been marked by a "weighty theological legacy" (65) It is due to this legacy that nudity has always only been what he describes as "the obscure and ungraspable presupposition of clothing," something that only appears when "clothes . . . are taken off" (65) Nudity, within such a theological optic, is nothing but the "shadow" (65) of clothing. Agamben's project in his text is to "completely liberate nudity from the patterns of thought that permit us to conceive of it solely in a privative and instantaneous manner," and therefore the focus of such a project will have to be "to comprehend and neutralize the apparatus that produced this separation" (66) between nudity and clothing. He considers such a project to be realized in Beecroft's performance, in which "a hundred nude women (though in truth,

10. Giorgio Agamben, "Nudity," in *Nudities,* trans. David Kishik and Stefan Pedatella, 55–90 (Stanford, Calif.: Stanford University Press, 2011). Further page citations are in the text.

they were wearing transparent pantyhose [and in some instances also shoes, as he points out later]) stood, immobile and indifferent, exposed to the gaze of the visitors who, after having waited on a long line, entered into a vast space on the museum's ground floor" (55). There are obviously naked—or sort of naked—bodies here, but Agamben's perhaps surprising conclusion at first (which I sought to echo earlier on) is that in Beecroft's performance, nudity did not take place: instead, everything was marked by that theological legacy that renders nudity into a presupposition of clothing.

And yet, Agamben finds in the performance something that might also neutralize this legacy, and more broadly the separation between nudity and clothing, and that is the indifferent and expressionless faces of the women in the performance. He argues, toward the complicated end of his text, that these faces practice a "nihilism of beauty" (88) that shatters this theological machine. It is the beautiful face that marks this machine's limit and causes it to stop by "exhibiting its nudity with a smile" and saying: "You wanted to see my secret? You wanted to clarify my envelopment? Then look right at it, if you can. Look at this absolute, unforgivable absence of secrets!" (90). Nudity can in this sense quite simply be summed up as: "*haecce*! there is nothing other than this" (90). Agamben goes on to describe the effect of such a stop as a disenchantment that is both "miserable" and "sublime" due to how it moves "beyond all mystery and all meaning" (90). There is no mystery to dispel, no meaning to uncover, no secret to be revealed. In nudity, all there is, is the beautiful face—and by "beautiful" he is not proposing an aesthetic judgment but marking precisely the indifferent appearance that is being described. It is, in this way, the beautiful face that frees nudity from its theological weight and lets it be, quite simply, naked.[11]

11. Agamben had made this point previously in "In Praise of Profanation." Even before then, this argument about the face can also be found in Giorgio Agamben, "The Face," in *Means without End: Notes on Politics,* trans. Vincenzo Binetti and Cesare Casarino, 91–100 (Minneapolis: University of Minnesota Press, 2000).

If art history and the ways in which it has shown nudity, after the seventeenth century more often through the veiled, partly unveiled, or fully unveiled bodies of women, is evidently burdened also by the theological weight that Agamben describes, then Kolsrud's paintings can be read as critically participating in Agamben's project. It seems clear that Kolsrud is aware of how nudity exists in the shadow of clothing. Indeed, her paintings stage reversals of nudity and clothing in a way that those figures who are naked in her work (I am thinking of the bathers) appear to be fully covered; whereas those figures or elements that are supposed to be clothed—the *Three Graces,* for example; the foot in the boot— appear to be naked. Such reversals recall the kinds of reversals that Agamben discusses in relation to Beecroft's work, where he references paintings of the Last Judgment, in which the angels are clothed and those awaiting judgment are naked, in an exact reversal of the situation in Beecroft's performance where the performing women/angels appear to be naked and the spectators awaiting judgment appear fully clothed, having just walked in from the cold Berlin streets. Even the faces of the figures in Kolsrud's paintings recall those expressionless faces that Agamben writes about, where a kind of halt to the infinite, theological striptease of denudation is enforced.

But Kolsrud's brilliant—and yet un-exceptional, in my analysis— contribution as a painter is that she turns painting itself into an ally in this context: indeed, I would argue that the possibility of calling a halt to the theological logic of denudation is at least equally shared between her figures' expressionless faces (I will leave it in the middle whether they are beautiful or not), and possibly even presented first and foremost by painting itself—by the fact that what her paintings ultimately show us is not a nude but naked painting (something much less exceptional). In this way, Kolsrud ultimately does not need Agamben's "beautiful faces" (and even less the "choirboy's 'white' voice," which makes an odd appearance in the closing line of Agamben's text) to block the theological machine. It is painting, rather—*naked, unexceptional painting*—that steps in

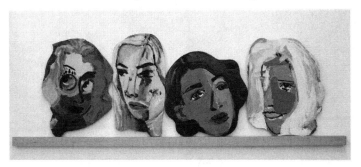

Becky Kolsrud, *Heads* (installation shots).

here to, in a kind of miserable but simultaneously sublime way (it retains a trace of the exceptional, after all), declare the absence of all secrets, the void of meaning. There is nothing to denude here, Kolsrud's paintings seem to say. Painting—*naked painting*—marks an end to denudation. In this sense, painting, for Kolsrud—naked, unexceptional painting—becomes a kind of weapon against the ways in which human beings, but in particular women, have been violently caught up in the exceptionalist painting of nudity.

And one can trace this argument even further back in Kolsrud's work. For if Kolsrud, some time in 2017, shifts to painting nudes (thereby situating herself critically in an art history of the nude), I am inclined to read this shift as a logical development from the faces or rather heads she was still painting during that same year. These need to be read, with some of Kolsrud's even earlier work (from 2016), in relation to the genre of the portrait that, like the nude, makes up a celebrated art historical *topos*. I write "heads," and not "faces," because that is what Kolsrud calls them: they appear like decapitated, slightly disfigured, women's heads (painted on what looks like a painter's palette), leaning against each other on a wooden beam mounted against the gallery wall, in one case. In another, different setup they don't lean but hang, separate from each other, on the gallery wall. One of those latter faces, or rather heads, appears to be doubled (a doubling to which I will come

back later on); another has the shape of a face, or rather a head, but is not recognizably a face—it is really just colors. A head.

Kolsrud's preference for the word "head" rather than "face" recalls, whether intentionally or not, Gilles Deleuze's writing about Francis Bacon.[12] In his book on Bacon subtitled *The Logic of Sensation,* Deleuze argues that Bacon, "as a portraitist . . . is a painter of heads, not faces, and there is a great difference between the two."[13] Whereas the face, and in particular the traditionally beautiful face, refers to a "spatializing material structure," a "structured, spatial organization" that for example the bones also bring to the body, the head is the culmination of what Deleuze describes as "the body as figure," and more precisely "the material of the figure."[14] As such, the face "conceals the head," and Bacon's project as a portraitist was precisely to "dismantle the face, to rediscover the head or make it emerge from beneath the face."[15] To do so means to open up a "zone of indiscernibility or undecidability between man and animal," Deleuze suggests, and he ties this particular zone back to the body, but specifically the body "insofar as it is flesh or meat."[16] Here, he has in mind something that is no longer "supported by the bones," a state where "the flesh ceases to cover the bones, when the two exist for each other, but each on its own terms: the bone as the material structure of the body, the flesh as the bodily material of the Figure."[17] Before one reads such materiality in a vulgar way, Deleuze is quick to emphasize in his text that it does not lack "spirit": the head is in fact "a spirit in bodily form, a corporeal and vital breath, an animal spirit. It is the animal spirit of man: a pig-spirit, a buffalo-spirit, a dog-spirit, a

12. Gilles Deleuze, *Francis Bacon: The Logic of Sensation,* trans. Daniel W. Smith (Minneapolis: University of Minnesota Press, 2002).

13. Deleuze, *Bacon,* 19.

14. Deleuze, 19.

15. Deleuze, 19.

16. Deleuze, 20.

17. Deleuze, 20.

bat-spirit . . ."[18] It is partly for this reason, it seems, that Deleuze can suggest that Bacon is a butcher, but a butcher who "goes to the butcher shop as if it were a church, with the meat as the crucified victim."[19] "Bacon is a religious painter only in butcher shops,"[20] he writes.

Kolsrud's heads share something with this Deleuzian reading of Bacon and with Bacon's project as a portrait painter in that they participate in the painterly brushing out of the clearly identifiable features of the face. But Kolsrud is not quite as universalist as Deleuze, who in his insistence on the head appears to gloss over the fact that Bacon is painting mostly men. Kolsrud, on the other hand, is painting women. She may be painting women's heads rather than faces, but they are still, in almost all instances, identifiably the heads of women. Perhaps something important is being said here about Deleuze's head and meat and the limits it poses for art historical analysis, or even the analysis of our lived experiences in the world, in the sense that it does not account for sex or gender, or also race or class. The head and meat are beyond those, for better or for worse.

As a materialist painter, a painter who foregrounds the materiality of painting, Kolsrud also retains something of what Deleuze calls "the spiritual." Going back to the most recent work from 2018, one should pay attention to scale specifically in terms of how the female bodies are situated in the landscape: it appears as if those bodies are bathing in large bodies of water—lakes rather than swim-holes—and thus the bodies appear unnaturally large compared to the landscapes in which they are situated. This appears to partly cast Kolsrud's female figures as spiritual or divine, bathing in a large body of water over which they don't so much rule but with which they become one. If I hesitate to fully associate these figures with "Mother Nature" or "Mother Earth," it is

18. Deleuze, 19.
19. Deleuze, 21–22.
20. Deleuze, 22.

not only because women have suffered this association for long enough already (and for better and for worse) but also because there are elements—shoes, nailpolish, lipstick—that also prevent such a full identification. The female bodies flow into the landscape and the landscape into the female bodies in the paintings, but Kolsrud's line nevertheless remains quite distinct, marking a clear limit between the landscape and the female body, and thus at the very least drawing such an association into question.

Still, there is spirituality in Kolsrud's material paintings, in a way that is similar to how the "spiritual" haunts "the material" in Chinese landscape painting. François Jullien points out in a chapter titled "Spirit" from his book *Living Off Landscape* that, in Chinese landscape painting, the spiritual is not separate from the material; or, as he puts it, "the aura is not brought to bear or added on (fake); it is one with the thing."[21] Indeed, Jullien opposes the (Chinese) landscape to the (Western) nude on this count. If Kolsrud's paintings need to be read within the exceptionalist, Western tradition of the nude, I am also suggesting that they be considered within the "bland," Far Eastern tradition of landscape painting.

When considering Bacon's intervention in the history of portrait painting, the politics of it appear to be clear: Bacon's heads mess with the practice of identification that the portrait participates in, as is evident for example from the portrait's legacy in the passport photograph. Although a trace of identification remains in Bacon's heads—they are, for example, all men's heads, something that Deleuze does not insist on enough—it is clear that Bacon's heads are trying to go beyond identification, to leave identifica-

21. François Jullien, *Living Off Landscape or the Unthought-of in Reason*, trans. Pedro Rodriguez (London: Rowman & Littlefield, 2018), 54. This point, which Jullien later articulates through reference to Walter Benjamin, leads into a (silent) opposition of Chinese thought to Kant: "China never carried the distinction between the sensible and its beyond into a metaphysical split, and was therefore at leisure to conceive of the spiritual's deployment as a phenomenon, as occurring within the physical" (57).

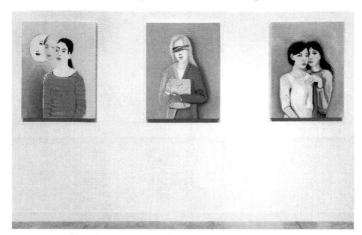

Becky Kolsrud, *Double Portrait (Moon), Double Portrait (Pink Hands),* and *Double Portrait (Hiding)* (installation shot).

tion behind (this is what Deleuze refers to as becoming-animal, becoming-woman, becoming-vegetable, and so on). Kolsrud, too, seems to have identification and its political history in mind.

When she paints portraits in 2016, she paints "Double Portraits," in other words: identifications that, because they are always already split, tend to make identification (which operates according to the logic of the "one") impossible. A face becomes two, becomes a head, and even a moon (*Double Portrait (Moon)*). In another double portrait, the eyes are painted over and the focus appears to be on the hands holding what is an image of a face (*Double Portrait (Pink Hands)*). This last element in the painting anticipates those works from 2017 in which female figures are shown to hold up a shawl or a towel for the viewer. In yet another of her double portraits, one of the portrayed faces is shown to be partially hiding behind its other (*Double Portrait (Hiding)*). Clearly, all of these works, as portraits, frustrate the process of identification and in that sense are part of the broader realm of what Deleuze has theorized as Bacon's heads.

That this frustration might be partly political, and intention-
ally political, is revealed by Kolsrud's other paintings from 2016,
in which eyes, heads, and full bodies are largely blocked from
view by what the painter explicitly calls *Gates* and *Security Gates*.
These "gated" paintings strike me as overpainted, even more so
than *Underwater Boot*, in that their gated representations ultimate-
ly show nothing more than paint, than painting itself—and this in
spite of the fact that they create the desire to see through the gate.
The gates function, in other words, as a kind of clothing: they set
up the presupposition of nudity behind or underneath the cloth-
ing, but Kolsrud's painting blocks that search for nudity that (once
again) is particularly intense around the bodies of women. The dy-
namic of denudation stops at the gated painting, at the painting's
gate, which is a kind of security gate not so much in that it would
imprison the eyes, heads, or full bodies behind it. The temptation,
then, would be to conclude that, instead, the painting allows those
eyes, heads, and full bodies to simply be—and that may certainly
be part of their point, a point that Agamben makes as well about

Becky Kolsrud, *Security Gates.*

"the beautiful face." But I have suggested that Kolsrud's painting actually goes further and does not so much allow the eyes, heads, and full bodies to simply be—and to simply be naked—but fore-grounds *painting* and ultimately allows *painting* to simply be. The search for nudity is not so much blocked here by the naked body, but by *painting itself.* Painting, in its spiritual materiality, brings that search to a halt and forces the viewer to rest with its surface, in the absence of secrets and the void of meaning. In that sense, one can call it naked—but naked only insofar as that nudity is a clothing liberated from anything that is supposed to be hiding underneath.

It shouldn't come as a surprise, finally, that some of Kolsrud's even earlier work, from 2014, focuses on clothing. It shows faces, or rather heads, as part of clothed bodies, or bodies in the pro-cess of being clothed (*The Fitting*; *We Alter and Repair (Shoulders)*; *We Alter and Repair (Back)*). It shows security gates, which are now revealed to be the fronts of sewing stores (*Storefront,* two paintings), where clothes get altered and repaired (*We Alter and Repair*). Anticipating the later portrait work, there is a *Seamstress* and a *Woman with Sewing Machine,* two figures that must, follow-ing the larger trajectory that I have laid out, be read not only as such but also in association with the painter herself, who treats canvas and paint as clothing. Thereby, Kolsrud paradoxically puts on display a nudity beyond denudation, a simple nudity that is not so much the nudity of the naked body but the nudity of naked painting, of a painting that materially and spiritually calls a halt to the theological and art historical striptease in which, for so many centuries, nudity has remained caught up. It is a nudity that para-doxically is its own clothing—and nothing more.

In that sense, Kolsrud provides an answer to the question about that most mysterious of terms in Agamben's work, form-of-life, which is to dismantle the vicious dynamic between *zoe* (the simple fact of living) and *bios* (form of life) that, as I have already indicated, is analyzed in great detail in Agamben's *Homo Sacer* project—but also in other texts that are not explicitly a part of that project, such as "Nudity."

Becky Kolsrud, *The Fitting.*

Let me explain how this is so by returning, once more, to Jullien's *The Impossible Nude.* Jullien's book is so valuable in part because it answers important questions related to both ontology and metaphysics for the Western philosophical tradition. Those questions also pertain to the notion of "form," which is go-

Becky Kolsrud, *Seamstress.*

ing through something like a revival in contemporary thought.[22] Consider a short little book that I already discussed in a previous chapter, Byung-Chul Han's *Shanzhai: Deconstruction in Chinese.* When Han discusses Western ontology and metaphysics, he characterizes Western thought as "monomorphic," adding the Greek term "monoeides" to mark Western thought's preference for the Platonic Idea or *eidos,* "Form."[23] But this rendering of "monomorphic," which is already a Greek term that falls apart in the words "mono" and "morphic," or "single" and "form," *as* the Greek "monoeides," "mono" and "eides," which also translate as "single" and "form" seems odd—unless the Greek words *morphe* and *eidos* both mean exactly the same thing? Han does not give this any further discussion. But it is on this count that Jullien shows himself to be the more interesting thinker, since he actually rises to the challenge of the divergence that these questions open up.

In what are in my view some of the more striking pages in contemporary Western philosophical thought, Jullien writes the following:

> For *form*, Plotinus uses two words in conjunction with each other, and often goes so far as to suggest that they can be synonymous: *eidos,* which is the idea-form—intelligible form, with ontological status, and *morphe,* which designates the contour that circumscribes matter . . . A similar ambiguity is to be found in the language of Saint Augustine: *forma* is used to mean (1) the model form (Intelligence, the Divine Word), (2) the external form that is the contour, and also (3) form perceived as the source of beauty. This should also be read the opposite way around: beneath the "plastic," visible form, we keep sensing the informing, ontological, model form. Now it is out of this very ambivalence that the possibility of the nude is conceived: the Nude is the embodiment of our quest for the model, archetypal, "primary form" to be reached through the sensible form. For the nude is not just one form among others: it is the form par excellence (the

22. See, for example, Caroline Levine, *Forms: Whole, Rhythm, Hierarchy, Network* (Princeton, N.J.: Princeton University Press, 2015).

23. Byung-Chul Han, *Shanzhai: Deconstruction in Chinese,* trans. Philippa Hurd (Cambridge, Mass.: MIT Press, 2017), 11.

Nude). It is the essential form that appears with the sensible, just as, in reverse, it is the sensible form rejoining the idea-form. In fact, through the Nude, we have tried unceasingly to find a hypostasis of Form. . . . And it is even the Nude which, because it is the most sensible—immediate to the senses, uncovered: laid bare—brings the two poles of plastic form (modeled relief and contour) and idea-form most directly into communication, within it-self. The plastic form uncovers the idea-form, and the last veil finally falls away; the idea-form ennobles the plastic form: we are in the very presence of the Idea, of the model and archetype. Hence the elevating tension of the nude: the tension is imparted by our metaphysical dualism. It gives rise to the transcendence summoned up by the nude—the vertigo of the extreme to which it leads: our awed amazement (*thambos*) at the nude (the ecstasy). At the same time, it melts (dissolves/resolves) this dualism into the sole unmediated possibility of perception—that which is *laid bare*: this explains the characteristic sense of satisfaction, concurrent and soothing, that we experience when we look at the nude.[24]

The identification of *morphe* (form as contour) with *eidos* (form as idea) that we found in Han is, Jullien reveals, common at least since Plotinus. However, when trying to understand the unique place of the nude in the Western art historical tradition (and its unique absence in China), one must remain attuned to the difference between *morphe* and *eidos,* and the way in which *eidos* continues to stir underneath *morphe.*

While the nude is obviously hylemorphic, in the sense that it combines matter (*ule*) with plastic form (*morphe*), the nude at the same time participates in ideal form (*eidos*), and its significance in Western art history comes from there—from its proximity, as a plastic form, to the ideal Form (and beauty). Pushing back against the identification of *morphe* and *eidos,* as Jullien points out Heidegger among others has done,[25] one senses "another possibility for thought," one that would sidestep the ideal Form entirely. Jullien finds this other possibility in China, which

24. Jullien, *Impossible Nude,* 66–67.
25. Jullien, 67.

"did not conceive of any intelligible form beyond the realm of the sensible, nor any immutable form that is an essence."[26] As Jullien argues throughout his work, China does not have metaphysics; it doesn't have being, only process. The Chinese term that translates as "form" is, Jullien points out, the notion of "xing," which "designates an ongoing actualization of cosmic energy-breath."[27] Form in China thus needs to be understood as "formation."[28] As Jullien recalls, "the great image has no form."[29] These arguments are repeated in his book *This Strange Idea of the Beautiful,* where Jullien underlines once more that in Chinese thought "No form stabilizes, no *eidos* is isolated."[30]

What we find here, according to Jullien since Plotinus, is a subtle fusion of Aristotelian ontology (the hylemorphic position) with the Platonic theory of ideal Form, which in fact made possible Western theories of art as allowing Form to appear through sensible matter/form. Thus Plotinus redeemed art from the discredit cast upon it by Plato, as Jullien points out.[31]

As I see it, this is the precise fusion that underlies Agamben's entire work, which takes as its starting point the Greek split between *zoe* and *bios,* the simple fact of living common to humans, animals, and gods, and ethical and political forms of life. In particular in the conclusion of Agamben's *Homo Sacer* trilogy, which begins with this split, it becomes clear that what Agamben is targeting is the biopolitics of Aristotelian ontology: the hylemorphism of "life" that underlies the entire Western political tradition. To overcome the hylemorphic split, however, Agamben proposes the enigmatic notion of form-of-life,[32] rendered in *The Use of Bodies*

26. Jullien, 67.

27. Jullien, 67.

28. Jullien, 68.

29. Jullien, 77.

30. François Jullien, *This Strange Idea of the Beautiful,* trans. Krzystof Fijalkowski and Michael Richardson (London: Seagull, 2016), 85.

31. Jullien, *Impossible Nude,* 91.

32. I have commented on this in. *Plastic Sovereignties.* Indeed, I would

as "*eidos tou biou,*"[33] a form—and I think we can say, given his use of the Greek *eidos,* an ideal Form—in which no *zoe* nor *bios* could easily be separated. In other words, Agamben recovers, from underneath the hylemorphic split that structures Western politics, the Platonic notion of ideal Form, something that he had been interested in since his earliest writings (as the essays on Plato in the collection *Potentialities* evidence[34]).

Given all of this, it should come as no a surprise that Agamben has written about the nude, and has characterized it—positively—in precisely the terms that Jullien suggests, as having the "impact of an immutable revelation: the 'everything is there,' 'this is it,' with no horizon or receding perspective, no beyond."[35] There are important differences between how Agamben and Jullien characterize this nudity: whereas Jullien associates it with an event, Agamben seeks to move away from such an association (he associates the theological understanding of nudity with the "event"[36] of denudation). Perhaps most importantly, Agamben's "there is nothing other than this" (which characterizes the face of beautiful women) differs from Jullien's "everything is there" in that it seeks to mark, precisely, a reduction of beauty to appearance that Agamben seeks to celebrate against a metaphysical model of nudity.[37] But while Agamben may find a defusing of theology and metaphysics here, his language reveals—and it is Jullien who enables us to see this—that this is hardly the ultimate defusing of

now say that in that book I was struggling with the concept of sovereignty as a key concept in the Western philosophical tradition, and was trying to unexceptionalize it from what, through reading Jullien, I have come to understand as a "Chinese" point of view.

33. Agamben, *Use.*

34. Giorgio Agamben, *Potentialities: Collected Essays in Philosophy,* trans. Daniel Heller-Roazen (Stanford, Calif.: Stanford University Press, 1999).

35. Jullien, *Impossible Nude,* 3.

36. Agamben, "Nudity," 90.

37. Agamben, 88.

Western thought, which continues its life in these quotes, precisely as Jullien suggests, as "aesthetics" (which steps in to fill theology's gap). In the nude, or rather the beautiful face of the nude, Agamben encounters the stop that, as per Jullien's reading, the nude in the Western tradition presents. But whereas Agamben stops at this stop, so to speak, by accepting how it defuses the theological apparatus in which the nude is caught up, Jullien enables us to see the hidden tensions of this stop, the ways in which in this stop, one hears *eidos* stir underneath *morphe.*

Indeed, if Agamben finds in the beautiful face of the nude and the stop it poses to theology the form-of-life or *eidos tou biou* he praises elsewhere, it is clear that *eidos* or the ideal Form is able to realize itself aesthetically for him in the beautiful face of the nude. If Agamben's teacher Heidegger opened up the possibility of a thought that would not identify *morphe* with *eidos,* and if Jullien considered here taking the path of *morphe* rather than *eidos,* Agamben goes the other way, back to Plato, and thus becomes the apogee of Western thought. Jullien notices many of the same things as Agamben does, but considers these in the context of the divergence between Western thought and Chinese thought. This leads him somewhere else, outside metaphysics and ontology. It leads away from an aesthetic of "the beautiful," outside of essence and Being. This leads away from the nude, or at the very least it would lead to a very different kind of nude. Try to conceive, he writes in *The Impossible Nude,*

of a "form" that would be seen only—as is the case in China—as the temporary actualization of the ongoing evolution proper to all living things. Think, therefore, of a body that is only the concretion (by individuation, and hence fleetingly perceptible) of the invisible underlying mass of energy in ceaseless deployment—actualization and resorption—as it forms the universe: the consistency on which the nude hinged disappears immediately, leaving no essence to be immobilized. My body comes into the world, grows, ages, and decays. It is constant prey to the transformation that brought it into existence, even though the process is so seamless that it is imperceptible to the eye. The body presents no durable (and much less any

definitive) state that might characterize it—the state immobilized by the nude—and I am aware only of different phases.[38]

If it is difficult—indeed, impossible—to imagine such a nude, I have already indicated where this description leads Jullien: to landscape.

All of this also means that while Agamben has become known as a thinker who criticizes political exceptionalism, his thought in "Nudity" ultimately remains caught up in the exceptionalism it contests. Jullien, by contrast,[39] operates in what could be char-

38. Jullien, *Impossible Nude,* 33.

39. The contrast is less marked in Jullien's books on Christianity: *De l'Intime: Loin du bruyant amour* (Paris: Grasset, 2013) and *Ressources du christianisme* (Paris: L'Herne, 2018). Similarly, but for wholly different reasons, the contrast is less marked in some of Agamben's other texts. There, the contraction of *zoe* and *bios* into an *eidos tou biou* is accomplished without a continued attachment to beauty. Eske Møllgaard has argued, for example, that in *The Coming Community,* Agamben defends an unorthodox kind of transcendence that needs to be opposed to the one of Plato's ideal Forms. This would be the idiosyncratic transcendence of "the very 'taking-place of the entities,' their 'being irreparably in the world,' the very fact '[t]hat the world is, that something can appear'" (Agamben qtd. Eske Møllgaard, "Zhuangzi's Notion of Transcendental Life," *Asian Philosophy* 15, no. 1 [2005]: 1–18 at 5). Note that there is no mention of beauty here. Møllgaard furthermore argues that this sense of transcendence that can be found in Zhuangzi and in Jullien's work on Zhuangzi also features in Møllgaard's text. Elsewhere, Møllgaard has put Agamben's sense of transcendence in dialogue with both Zhuangzi's understanding of the Tao and Heidegger's notion of "releasement" (*Gelassenheit*) (Eske Møllgaard, "Dialogue and Impromptu Words," *Social Identities* 12, no. 1 [2006]: 43–58 at 54). The relation of Agamben to Jullien warrants a much longer discussion that would need to consider Jullien's book on Plato (*L'Invention de l'idéal et le destin de l'Europe* [2009; Paris: Gallimard, 2017]) and what Mathieu Potte-Bonneville has called Jullien's "anti-platonisme fécond" (Mathieu Potte-Bonneville, "Versions du platonisme: Deleuze, Foucault, Jullien," in *François Jullien, ed.* Daniel Bougnoux and François L'Yvonnet [Paris: L'Herne, 2018], 51–58 at 52). The relation of *eidos* to *telos* would need to be considered here as well, especially in view of the emphasis Agamben has placed on a philosophy of "means without end."

acterized as *the unexceptional Far East*.[40] And it is there, I have argued, that Kolsrud's naked painting and its critical engagement with Agamben can also be found.

40. By this phrase, "the unexceptional Far East," I am partly trying to draw out the peculiar fact that the name "Far East" itself carries connotations of "exceptionality" in French: *l'Extrême Orient*, the "extreme" Orient. All of Jullien's work arguably targets this peculiarity.

Conclusion: Unexceptional Rubens

IN APRIL 2018, it was reported that a self-portrait by the Flemish master Pieter-Paul Rubens had returned to the painter's old atelier in the Rubenshuis in Antwerp (Flanders, Belgium) after a year of restoration by Marie-Annelle Mouffe from the Royal Institute for Cultural Heritage. As part of that process, Mouffe had removed several layers of varnish, and multiple additional layers of paint, of a painting that was for 75 percent painted over. Many accents had been added to the original painting over time. The restoration also revealed that the painting had existed in different formats: it had been enlarged, for example, and even been turned from a rectangular into an oval shape, the trace of which is faintly visible in the restored original. Such material changes are related to changes in ownership. Those who owned the painting also left a material mark on it.

It is interesting to consider the different kinds of changes that are listed here, from changing the shape of the painting to adding accents to the painting, or even painting over parts of it. The value of the Rubens painting was, of course, never in doubt. Nevertheless, the painting had—until now—only been showing about 25 percent of its original paint. It was considered an original Rubens, even if many others had also had a hand in it. Because it was a Rubens, the painting received the expensive restoration that revealed this. But it raises questions about many of the other paintings we see in museums as well: to what extent are they, too, painted over, and many layers removed from their original state? To what extent have they, too, had accents added, a layer of varnish added, or their format changed? To what extent do they, too, show, in their material history, the traces of their private owners, before they ended up as public property in the museum? To what

extent do these material histories, these unexceptionalizing accounts of masterpieces, undermine the exceptionalist attachment to the original that structures Western museums today?

To what extent, finally, do such material histories place Western art in close proximity to the classical or ancient Chinese art that Byung-Chul Han describes, a proximity that the art market would rather wish to deny?

And given that such a denial rests on a denial of painting, of the very worldly practice through which even a masterpiece such as Rubens's portrait came about, isn't it interesting that Rubens presents himself in the painting as a nobleman rather than a painter—that he did not want to be known as a painter—as if he was dissimulating the very worldly craft that was so obviously on display in this portrait of the master by his own hand? By wanting to be recognized as a nobleman, Rubens contributed to the institution of exceptionalist art, a development that the painting's material history unworks, all the way into the painting's original layer (which the museum's director in an interesting turn of phrase described as being close to Rubens's "skin"—showing a kind of bare or naked Rubens, in other words). Far from confirming the exceptionalist status of art, and Rubens's status as a nobleman, the painting's restoration draws out something utterly unexceptional about the painting, uncovering the painter underneath the nobleman, and reminding all of us through the painting's material history (which is also the history of its ownership) of how unexceptional, in the end, art really is.

Acknowledgments

I owe the term "aesthetic exceptionalism" to Olivia C. Harrison, who casually suggested it one late night when I was struggling to come up with a lecture title. Thanks to Michael Pisaro for his help with the permissions request for reproducing the Courtney Barnett lyric. My research assistants Claudia Grigg Edo and Carl Schmitz (sic!) saved me much time and effort. I am grateful to my friends Sarah Brouillette, Alex Robbins, and Martin Woessner for their insightful comments on various drafts of the manuscript. I also want to thank Becky Kolsrud for welcoming my interest in her work.

Arne De Boever is faculty in the School of Critical Studies and director of the MA Aesthetics and Politics program at the California Institute of the Arts. His works include *States of Exception in the Contemporary Novel, Narrative Care, Plastic Sovereignties,* and *Finance Fictions.*